Film, Nihilism
and the Restoration
of Belief

Film, Nihilism and the Restoration of Belief

Darren Ambrose

Winchester, UK
Washington, USA

First published by Zero Books, 2013
Zero Books is an imprint of John Hunt Publishing Ltd., Laurel House, Station Approach,
Alresford, Hants, SO24 9JH, UK
office1@jhpbooks.net
www.johnhuntpublishing.com
www.zero-books.net

For distributor details and how to order please visit the 'Ordering' section on our website.

Text copyright: Darren Ambrose 2012

ISBN: 978 1 78099 245 7

A CIP catalogue record for this book is available from the British Library.

Design: Stuart Davies

Printed and bound by CPI Group (UK) Ltd, Croydon, CR0 4YY

We operate a distinctive and ethical publishing philosophy in all
areas of our business, from our global network of authors to
production and worldwide distribution.

CONTENTS

Acknowledgements

Thanks to Siobhan, who has offered unwavering support throughout the writing of this book. She made careful and incisive copy-edits and has provided an invaluable dialogue on its contents. She frequently restored my courage to pursue and complete the project on those occasions when I completely lost faith in it. It simply would not have been written without her generous help and support.

Thanks also to Tariq at Zer0 for taking the risk on publishing this work.

This book is dedicated to my daughter Holly, herself a talented filmmaker, who shares my deep love of film.

Introduction

A Long Time Ago, In a Galaxy
Far, Far Away...

When I see a great film it stuns me, it is a mystery for me.
What constitutes poetry, depth, vision and illumination in
cinema I cannot name.
Werner Herzog

For me cinema began with *Star Wars*. I was ten years old and my
exposure to cinema had consisted of Disney seasonal matinees. I
remember not really considering the cinema to be all that
different from the television that we had at home, except that it
was bigger, louder and in colour. That changed in 1978. Within
seconds of the opening scene with the vast imperial space cruiser
pursuing the diminutive rebel ship through the depths of space I
remember becoming suddenly aware that I was in the presence
of something powerful and mysterious. It was, at least in part,
down to what I was seeing and hearing, and also to what I was
feeling.

Looking back, it was as if the spectacle of the cinema
suddenly came into view and was both visually and aurally
overwhelming. The film stretched my imagination. It trans-
formed my understanding of the world in a way that nothing I
had previously seen had managed to do. The world was
irretrievably altered, stretched somehow and now filled with
unknown possibilities. As a child this was a powerful and
memorable experience. Despite the conventional simplicity of
the film's plot and narrative I remember leaving the cinema with
only the sketchiest impression of the story; what made such a
lasting impression upon me was the overall affective power and
transformative effect of the film. As we left the cinema I actually

felt different as a result of what I had just seen on the screen.

I have always remembered this particular cinematic experience as being full of surprise – liberating and extraordinary. It was as if a previously unrecognised part of me had been awoken; another larger self residing at the back of my young head had made its presence felt as a result of encountering this film. I had been relieved of the burden of my ordinary everyday self in order for another, infinitely stranger me to emerge. In a significant way, the cinema's capacity for providing this type of powerful and liberating experience was crystallised for me at this screening of *Star Wars*, back in 1978.

Over thirty years later I sometimes think, rather romantically, that my boyhood experience of the cinema must have been a little like those ancient initiations that once took place in the painted caves of prehistoric Europe. Here too, in a close collective darkness, imagination had been subject to a strange and mysterious spectacle of something other, becoming yoked to the tail of dancing beasts and flown to vertiginous atavistic heights and depths previously unsuspected. It is entirely possible, if not highly likely, that one also left these underground spaces transformed both in terms of one's own sense of self and also in how one subsequently viewed and behaved in the everyday world outside.

I don't think that the type of experience of cinema I am describing can be reduced to escapism, certainly not in the sense that this term is often pejoratively applied. However, I do want to argue that the idea of escape does remain an important ongoing element of this form of cinematic experience. It is not, however, an escape as a flight from harsh and brutal reality into a de-realised fantasy realm. Throughout this book I want to suggest that the cinema can provide us with a collective opportunity for escaping our normal patterns of thought and the stultifying mono-dimensional quality of our everyday world. It can offer us a chance to momentarily plunge into the vertiginous realm of

illusion and the imagination. The difference from many other forms of escape is that cinema can offer us a way of resisting the homogenous reality of the present whilst rejuvenating an altered sense of reality which is revealed as having hidden dimensions and possibilities for action. In that sense it has the capacity for liberation as well as the power to restore a faith in the reality of a world filled with transformative potential.

The emergence of such renewed faith within certain forms of cinematic experience is at the heart of the argument of this book. I am not proffering a cinematic variation on vague and fashionable pop-mysticism. I want to indicate the extent to which cinema can play a decisive and concrete role in undermining the confines of our contemporary modes of perception and the mundane nihilism that has become so prevalent within everyday life. The cinema can offer much more than mere illusory flights of fancy, action-packed spectacles and dramatic representations to relieve the boredom of the prosaic state of affairs we find ourselves in. At its very finest and most ambitious the cinema offers us renewed hope of perceiving and thinking reality as teeming with new and previously unforeseen possibilities.

Throughout my own life the type of surprising cinematic awakenings that began very simply with *Star Wars* have continued to play an important role, albeit it in different and more complex ways. These cinematic experiences, like signal fires stretching through the darkness of modern times, have contributed immeasurably to the formation of my sense of self, others, and my relation to the world. In this book I will argue that such experiences, despite being rare, signal an implicit power of the art of film that must be harnessed and mobilised in this time of devastating economic and cultural nihilism. I continue to believe, despite the common-sense clichés that explicitly govern the majority of its contemporary manifesta-tions, that cinema has a vital cultural, political and aesthetic significance. As I will argue, this is a consequence of its

3

continued ability (albeit seldom employed) to challenge and remodel our habitual modes of perception through counter-sense, to question the present state of affairs in the world, to revitalise our ability to think and to make visible new possibilities for living.

Film can, and indeed must, play a vital role in breaking established and habitual ways of seeing and behaving. All too often contemporary films simply reproduce the ideology of the present by normalising (or naturalising) a certain form of 'common-sense' perception. For such an ideology there is only one way of seeing the only one way of being. Film has the power to enable us to see through the pernicious clichés and truisms that structure the homogenous field of what Mark Fisher has called capitalist realism. In the hands of a few directors throughout its history, film has repeatedly shown itself to be adept at not only developing ways to reproduce the perceptive norms associated with the present but of exposing their inherent limitations and performing vital interventions in an effort to produce perceptual and ontological variation.

As Fisher has so powerfully diagnosed in his book *Capitalist Realism*[1] the shrinking reality of our present is one where scepticism, nihilistic indifference and hopelessness have taken hold. The ontological texture of the world has become levelled through its reduction to instantaneous mass-media representation and its almost complete manipulation by capitalist market forces. Everything has slouched towards becoming surface without depth – a simulacra, a screen. Many feel, and are in a real material sense, alienated from this surface, having lost any semblance of a firm grasp upon its smooth and depthless skin. We have all become marked by less and less commitment to the reality of the world in terms of its past and its future. We exist confined to the present, unencumbered by either the layers of the past or alternative visions of the future; we exist floating in a frictionless state without any coordinates other than those

4

prescribed by capital.

When the sincerity of our commitment towards the world has been so remorselessly and fundamentally eroded is it any wonder that nihilism and despair begin to take hold? Cultural nihilism is intimately bound up with the crushing effects of the relentless logic of capital. Ensnared as it is within ontological coordinates governed entirely by the boring, repetitive cycle of capital and its associated ideology, our thought shrinks down around an ever-decreasing set of possibilities. Is it really a mystery as to why so many people have no more faith in the images of reality propagated by the media than in the actual reality of the world it ceaselessly and frenetically presents? Such a terrible form of ontological nihilism cannot be addressed through the cultivation of greater knowledge and clearer certainty alone, it must also be addressed through a rejuvenated sense of our own capacity to transform and rediscover the world.

In other words, it is as much about discovering the means to overcome ourselves and to become something else, the coordinates of which will not be found in the conditions of the present. This might well be described as a process of re-enchanting a world that has become fatally banalised, commodified, stratified and ontologically eroded by the viral forces of contemporary capitalism. Re-enchantment requires the emergence of a vital faith in the possibility of living differently again; of seeing, thinking and being in ways that can circumvent the myopia of the present where certain disastrous drives and desires have been unleashed and allowed to dominate all life. Central to the aims of this book will be the idea that a certain form of cinematic experience and the transformative effect it has upon our modes of perception and thinking has a crucial role to play in the vital re-enchantment of the world. The cinema can and must have a role in challenging capitalist realism by presenting not only alternative visions of possible realities, but alternative and unorthodox ways of thinking. This is the cinema of counter-

sense.

This book takes seriously the proposition that film is a material form of thought, one composed of moving images and sound. It also takes the view that many contemporary popular films continue to savagely reproduce a mono-dimensional form of thought to such an extent that they represent little more than filmic analogues of dominant cultural patterns of thought. Cognitively the experience of watching and experiencing so much contemporary film is akin to the cliché, a tedious doubling where one places one's feet over and over again into smooth and well-worn footprints. In thinking of film as a material form of thought I want to explore whether it can ever embody a different way of thinking and achieve a genuine degree of autonomy, or whether it is condemned to reduplicate pre-existing habits of thought. Where are the aberrant paths that might lead us down new, fresh and undiscovered byways in thought? Is film still capable of challenging the prevailing modes of thought and of producing an affective shock to our established ways of thinking? Can film appear as something 'outside' of thought, as an 'alien' form? Can film operate vertiginously despite its increasing quantitative banality, and provide us with much needed adventures in thinking? Can we be disturbed, disrupted, disorientated and awoken from our habitual cognitive slumbers? Can cinema be harnessed as an effective tool to subordinate ordinary habits of thinking, projecting thought into different realms, operating as a mitigation to the deep levels of stupidity that abound in contemporary culture?

After an initial discussion of orthodox cinematic realism and naturalism in Chapter 1, I will introduce some of the ways by which a number of filmmakers have grasped the vocation of resisting and transforming the perception and presentation of the present through the development of new cinematic forms. The way these filmmakers have contributed to the cultivation of diverse new forms of social relation, thought and belief in the

world will be discussed in relation to specific films. In Chapter 2 the orthodox ideology of social relation on offer in the contemporary genre of apocalyptic cinema will be analysed through Stephen Spielberg's *War of the Worlds* and M. Night Shyamalan's *Signs*, before introducing the Austrian director Michael Haneke's open, fragmented and reflexive cinema through looking at the way he reconfigures social relations in his own post-apocalyptic masterpiece *Time of the Wolf*. Chapter 3 will reflect upon the capacity of cinema to articulate new modes of thinking through its attempts to approximate the waking dream where thought is taken for a walk into the unknown along an aberrant path. This chapter will look at a variety of work by the American director David Lynch. The final chapter will conclude with a discussion of cinema's extraordinary capacity to present a renewed belief in the world by looking at a variety of documentary work by the German director Werner Herzog.

Confronted by a profound cultural malaise, this book will put forward the simple idea that encounters with certain forms of cinema retain a powerful transformative potential. Amidst the sheer plethora of stultifying and deadening multiplex fodder churned out by Hollywood, this book advocates those rare cinematic works which are capable of producing new effects, of altering the ways things are and making a difference to how we think and feel. Such films can transfigure our perceptual and cognitive capabilities, generate a renewed faith in a reality of constant change and becoming, and resist the ceaseless representation of the current state of things. These are the films capable of refusing the nihilism of the simulacra and of rediscovering the world.

I

Cinema, Realism and Naturalism

The cinema can offer very little that is new; everything that is said has been said a thousand times, but cinema still has the capacity, I think, to let us experience the world anew.
Michael Haneke

Captivation

Popular cinema can enthral and captivate us, holding us within the frame of its audio-visual spectacle, but rarely does it attempt to fully submerge us in a disturbing maelstrom of intense affects and mysterious questions. One of the critical claims of this book is that there are films that go beyond the orthodoxies associated with popular cinema, and enable us to perceive things otherwise. There are films that profoundly disturb our perceptual habits and patterns of thought, and suggest new ways of perceiving the world, new emotional affects and new ways of thinking. But first I will start with an account of the undeniable power of popular cinema.

When we sit in a darkened cinema immersed in the onscreen spectacle it is sometimes difficult to remember that what we are actually seeing is not a natural object. The often lengthy credit sequences that come at the end of most films, which audiences seldom watch, should serve to remind us just how complex and artificially constructed these objects actually are. Hundreds of individually shot sequences, dozens of script revisions, artificially constructed locations, complex post-production and editing, the increasing use of computer-generated images, and the addition of a soundtrack are all normal features of these objects we take for granted as naturally constructed things. Films possess a strange capacity for lulling us into believing them to be

natural objects along with other natural spectacles in the world. This does not mean that we simply believe in the entire variety of things we see screened, or that we are duped into literally believing in Middle Earth, extraterrestrials, zombies, government conspiracies, or global annihilation. Rather, whether we are sceptical, bored, excited, emotionally moved or thrilled by what we see, we often remain unquestioningly committed to the ontological reality of the appearance of the object as filmed. We seldom experience any genuine awareness of the artificiality of the medium. The degree of commitment to film's ontological reality is greatly influenced by the current state of technology and visual effects. Older films, where the visual effects are considerably more primitive, are often condemned to becoming limited and artificial in terms of their ontological realism. Our enjoyment of such films is allegedly disrupted by the emergence of their visual limitations over time, the outdated filmic technology producing an inadvertent and unintended ontological disturbance. As cinematic technology advances most films continue to display this uncanny ability to appear, and go on appearing, as a natural object to our modes of perception.

Arguably, the most prevalent and debilitating cinematic myth is that of realism and naturalism – the cinematic world is taken to be an ontological analogue of a real world. How is it that film manages to achieve this? I think that the answer to this question lies in a detailed reflection on what makes up film's material quality, together with a consideration of certain developments in film form and its peculiar ability to emulate normal and established perceptual processes in the minds of the audience. In classic Hollywood films of the 1930s and 1940s a set of clearly defined orthodox techniques emerged for establishing the filmic realm as an analogue of the existing world. These techniques became habituated, naturalised and established, operating invisibly and seamlessly within much mainstream film today. Most popular films continue to display an organic unity of time,

either as a presentation of a continuous duration that mirrors real time or as an assemblage of discreet and separate durations that are integral and consistent. Their space is usually a definite locale, either in terms of utilising geographically specific 'real backdrops' – e.g. the cities of New York, Los Angeles, San Francisco, London, Tokyo, etc. – or recognisable/familiar locales (often artificially constructed in studio lots) – e.g. domestic interiors, offices, prisons, streets, vehicles, forests, deserts, and mountains. All of these filmic spaces, despite often being entirely artificial assemblages in terms of their 'real' geography, are more often than not filmed and presented as unified, consistent and coherent.

Film and Photography

One of the most fundamental elements contributing to cinema's remarkable ability to appear as something entirely natural to our perception lies in its material origin within photography. As many early film theorists such as Andre Bazin and Erwin Panofsky recognised, there is an intrinsic ontological link between photography and film, insofar as the basis of the medium of film is essentially photographic. Both theorists also recognised that a photograph involves an effective transfer of reality into an artificial visual media. Traditionally, photography is a process of mechanically recording an image of the world through mechanical registration of reflected light onto a prepared photosensitive chemical surface, e.g. dating back to the calotype process introduced in the nineteenth century by Fox Talbot. The length of the exposure of light onto this prepared surface effects a remarkable transformation of material substance into an image where time, light and density are directly proportional. The resulting photographic image is an analogical one; in other words, it is, through mechanical means, a direct and continuous transformation of material substance that is isomorphic with the original image of the world. In fact, there is

a remarkable isomorphism between a photograph and the world with a very specific form of causality at play.

In the photographic process there is a transformation that is continuous with a given duration of time that makes up spatial images. Photographs are analogical in the sense that the representations produced during the photographic process are continuous and indivisible from the world they represent. Visual inputs are directly and continuously transfigured into durable material outputs through an analogical process. As Andre Bazin writes, 'the production by automatic means has radically affected our psychology of the image. The objective nature of photography confers on it a quality of credibility absent from all other picture-making. In spite of any objections our critical spirit may offer, we are forced to accept as *real* the existence of the object reproduced, actually re-presented, set before us, that is to say, in time and space. Photography enjoys a certain advantage in virtue of this *transference* of reality from the thing to its reproduction... The photographic image *is the object itself*, the object freed from the conditions of time and space that govern it.'[1]

Despite the fact that photographic representations have become ubiquitous, whenever one thinks about their peculiar quality as *analogical* objects there remains something deeply unsettling, seductive and immersive about them, which perhaps accounts for some of the enduring power of cinema. Let us reflect for a moment on what it is that photographs can do. All photographs, whether they are images of people, things, or landscapes that are familiar or not, present us with a world from which we are absent *at that moment*. As the American philosopher Stanley Cavell writes, 'when we look at a photograph we see things that are not present.'[2] At the moment of viewing a particular photograph I am screened from the world it presents by an enduring temporal absence. Yet the photograph's inherent realism (via its analogical transference) often activates the sense that there is a world represented in which I can still hope to

reconnect or rejoin since it is so much part of the fabric of reality in which I already exist and in which I am immersed. In other words, the fabric of the world represented by photographic images is recognisably the same fabric within which I exist at present. An ontological continuum exists.

As part of their material basis, all photographs embody an ontological nostalgia. They offer us the paradoxical perception that things which are absent in time, such as our youth, friends and family, the landscapes and places of our life or the events of world history, can all be made present to us in the space within which we exist. Photographs present us with recognisable existences in which we can believe and in which we are pulled towards, but with a simultaneously unbridgeable temporal distance. This yawning gap in time, coupled with the extreme analogical presence of the reality of the material image, has its own peculiar affectivity. In such moments we are not only held at a distance from the photographed world, but this world is screened from us. We *feel* the ache of our own absence from the view of the world being presented by the photograph – it is a view that is screened *for us* in space but screened *from us* in time. Suddenly space becomes temporally complex in a directly affective way. Clearly, photographs are rarely ever just neutral documentary objects, they invoke certain existential claims on our own acts of viewing them. Indeed, despite their ubiquitous quality, photographs continue to have the capacity to force us to reflect upon our own ontological situated-ness – i.e. how we relate ourselves to the past, present and future, and provoke a variety of complex affective states.

As Stanley Cavell argues, the historical invention of photography and film emerges as a response to a peculiarly post-Enlightenment desire for realism. More specifically, it emerges from a desire for a deeper metaphysical contact with a reality from which we have become increasingly estranged.

Photography satisfied a wish...the human wish, intensifying in the West since the Reformation, to escape subjectivity and metaphysical isolation – a wish for the power to reach this world, having for so long tried, at last hopelessly, to manifest fidelity to another.[3]

According to Cavell, the pre-Enlightenment era was oriented by a metaphysical fidelity to God which was subsequently eroded. This original religious fidelity to a metaphysical idea guaranteed a powerful sense of social and collective identity. However, during the Enlightenment old religious certainties were fatally eroded resulting in the modern subject of scientific empiricism becoming progressively detached from any collective grounding commitment, and increasingly alienated and confined within itself. Since the living notion of God retreated and no longer anchored a collective meaning in the world, the epistemological and moral responsibility for discerning meaning from nature fell more and more upon the subject alone. However, this confinement to subjectivity led to an insoluble epistemological crisis where humanity and nature became alienated from one another. For Cavell, the discovery of photography and film responded directly to this profound metaphysical dilemma. It operated as a kind of mechanical reconciliation device for the modern isolated subject. Their emergence directly answered to a deep metaphysical need of the subject, i.e. the need to view the world freed from its confinement within its own subjectivity and to see it as it actually is, anonymously and unseen. One finds here a desire on the part of the subject to regain a deep level of contact with the world through perceptions of it which are analogous to the level of contact it may have once felt, as part of a collective, towards the transcendental religious world in the pre-Enlightenment era. For Cavell, this indicates a powerful modern ethical dilemma, namely, how do we overcome our subjective estrangement from the world and restore a sense of

connection to it?

By discovering and elaborating a mechanical means for producing and fixing analogical images of the world, photography and film served to displace the solipsistic sovereignty of subjective perception; yet in doing so it offered a renewed opportunity for reconnecting to the reality of the world in a much deeper and more profound way. Within the analogical transfers of photography and film, humanity and the world are once again cast into an ontological continuum and become integrated into a shared duration. Humanity and the world objectively appear as sharing the same ontological substance and as having the same epistemological nature.

An important element in explaining our sense of the naturalised reality of photography and film consists in the way the represented world of the image directly responds to our modern metaphysical condition. They continue to offer us a means for reconnecting back to reality. As subjects we are able to repeatedly re-view analogically objective images of the past, in the present moment. Through them we are able to reconnect the represented moments of the past to the actual contemporary moment that it inhabits but which is ceaselessly passing away. In the cinema we are able to watch, again and again, Humphrey Bogart and Ingrid Bergman as Rick and Ilsa, captured and preserved there onscreen in an imaginary Casablanca of 1942. Or we can repeatedly re-view the young Orson Welles, captured and preserved in 1941, as Charles Foster Kane. There is something both magical and monstrous about this particular filmic capture and preservation. Just recall the grotesque ageing movie-star Norma Desmond in Billy Wilder's *Sunset Boulevard*, who spends her evenings repeatedly screening old silent films of her young self preserved forever on film. The image of herself as young and beautiful, captured onscreen, has her enthralled in a reverie of impossible nostalgia, haunting and tormenting her as she fades into septuagenarian obscurity. Just consider the peculiar nature

of our relationship to photographs and films (cine or video) of our own families and friends as time passes. Such photographs confront us with very powerful ciphers for the vertiginous quality of duration and the ephemeral quality of time passing, yet they hold out a means for anchoring oneself within this vortex. Is not this power equally magical and haunting? Photographs and films offer us the chance to preserve our connectedness to the past, yet in doing so they force us to think much more deeply about the present moment in time.

Film and Classic Continuity

Another crucial element contributing to cinema's ability to appear as something natural to our perception lies in the development of classical continuity editing. The basic function of the continuity system is to create a smooth flow between different shots. Through being situated in a unified and consistent temporality in recognisable and definable spatial locales (enabled through their photographic ontology), most conventional films are organised and edited primarily through the continuous dynamics of action narrative. This form of editing dynamic binds all of the depicted action into a tight chain of cause and effect where different events are linked through a transparently readable series of associative chains which occur in ordered space and time. The space of each scene is constructed along an axis of action, where it is assumed that everything takes place along a discernible, predictable line. This ensures the perception of common space from shot to shot. Space is delineated clearly. As a viewer I know exactly where characters are in relation to each other and to the setting. I always know where a character is with respect to the unfolding narrative action. The space of the scene, clearly and unambiguously articulated, does not jar or disorient; such disorientation would distract me from the centre of the action (and, therefore, the narrative chain of causal associations). So powerful is my desire to follow the action flowing

across the edits in classical continuity film that I tend to either ignore the cut or am simply unaware of its presence. Psychologically the similarity of movement and milieu from shot to shot holds my attention as a viewer more than the differences resulting from edits.

One of the enduring characteristics associated with classic Hollywood cinema is its insistence upon constructing continuity narrative on the assumption that the primary active forces are embodied within the individual characters who act as causal agents. Hollywood has refined and accelerated this fundamental narrative strategy to such an extent that it has become almost entirely 'naturalised' within the minds of contemporary audiences. Indeed, much contemporary film theory operates on the dubious assumption that the dominant narrative convention of classical Hollywood continuity cinema appears the way it does, and is so successful, simply because 'that is how the mind actually works'. However, it is surely just a convention that has such a powerful grip as to have become effectively naturalised in the mind of audiences. Consider just two short and very different sequences that might be considered emblematic in this regard.

The first is the opening sequence from Alfred Hitchcock's 1958 film *Vertigo*, which immediately follows Saul Bass's wonderful opening titles, and consists of a night-time rooftop chase in San Francisco. The sequence begins with a close-up of an iron rung followed by two hands gripping it. The camera pulls back to reveal a figure pulling himself up a ladder onto a rooftop, and he runs out of shot. He is closely followed by a uniformed police officer carrying a gun. Within seconds the inferential association has been clearly established for the audience – this is a pursuit, in fact it is a dangerous pursuit signalled by both the height of the location and the police officer's weapon. The uniformed policeman is closely followed onto the roof by a plain-clothed figure (played by James Stewart) – the clear logical inference at this point being that he is the detective in the scenario. We then

cut to a panning shot of the San Francisco cityscape (clearly signalled by such iconic locations as the Golden Gate Bridge visible in the shot), emphasising and underlining for us the perilous height of this pursuit. Two bullets are fired by the policeman during this part of the pursuit. We cut to a shot of the pursued figure leaping across a gap between buildings onto an adjacent roof and successfully pulling himself up and over. He is then followed by the policeman, who also leaps but is shown to slightly stumble and slip before also successfully pulling himself up and over. This logical sequence quickly initiates an immediate sense of suspense for we the audience realise that the figure of the detective now must also make this leap. In fact, as the detective leaps he stumbles, slips and is shown falling off of the roof. He is left hanging from a gutter by his fingertips. We immediately cut to a shot of the policeman who realises that the detective has fallen, and he looks back and makes the decision (a seemingly natural decision for us) to go back and help. We are shown the detective hanging desperately from the gutter and staring down at the city several storeys below, and at this point Hitchcock introduces his famous 'vertigo' zoom shot as we are shown the first-person perception shot of the detective's vertiginous experience of heights which freezes him in terror. The policeman leans over and encourages the detective to 'give me your hand', but the detective is rigid with fear. The subsequent shots accentuate the extreme peril as we are shown the detective shot from above as he hangs from the rooftop. The policeman leans out further to try and reach him but slips and is shown falling to his death. With absolutely minimal dialogue, relying solely upon the logic of the edited sequence of images, Hitchcock manages to convey all of the salient narrative information, as well as a good deal of suspense, terror and anxiety, in the most efficient and 'natural' way. By the end of this short sequence we know that the plain-clothed character played by James Stewart is a San Francisco police detective, that he has a incapacitating fear

of heights, and that this incapacitation contributed to the death of a policeman. These three key pieces of information are absolutely vital for understanding the subsequent events of the film, and they are all conveyed through filmic sequencing alone. Crucially this sequencing is immediately accessible and cognitively transparent to audiences watching the film.

The second sequence to consider is the first scene from John Ford's classic 1956 Western *The Searchers*. The scene is prefaced with 'Texas, 1868'. The door of a house opens out onto the iconic Western landscape of Monument Valley, and as a female figure slowly moves outside so does the camera. In the middle distance we see what this woman is looking at: an unidentified figure approaches on horseback. Through a reverse shot we are shown this woman standing on the porch straining to see who this character is, and it is clear from her lack of recognition that this is no one familiar. We are then shown the character on horseback getting steadily closer to the house, and the women being joined on the porch by a similarly aged man (who we naturally assume, correctly, to be her husband), and he looks equally perplexed by the appearance of this figure. We then cut to a different camera angle on the porch and we can see that the husband and wife have been joined by two young women (their daughters) and a dog. They are all intrigued and puzzled by the approaching stranger. Next a young boy joins them (the son) to watch the man on horseback. We cut to a shot of the dog barking at the stranger, further accentuating the sense, in the mind of the audience, that this is an unfamiliar character, possibly even a threatening one. We cut back to a shot of the man arriving in front of the house and dismounting before cutting back to a shot of the elder daughter who exclaims 'That's your uncle Ethan!' We cut back to this character Ethan, now recognisable as being played by John Wayne, who approaches the older man (his brother). He appears to be wearing a confederate army uniform, which allows the audience to infer the return of a character some three years after

the end of the Civil war. This is not a threatening stranger but a family member returning home after being away for a very long time. He soberly shakes his brother's hand before being tenderly welcomed by his brother's wife. The sequence ends with a shot of all of the characters moving back into the house. Like Hitchcock's opening sequence in Vertigo, this scene establishes a significant amount of salient narrative information and emotional tone in the most efficient and 'natural' fashion. We are introduced to all five members of this family living in an isolated and vulnerable home in the desert, the character of Ethan is introduced as an absent figure from the past, and he is clearly identified as a confederate soldier returning long after the end of the war. Again, this narrative information is crucial to the subsequent events of the film, and is necessary for the audience to be able to easily follow and emotionally identify with subsequent actions and events.

How do the conventions at play in classic sequences such as these actually work, and how do they manage to present themselves as 'naturalised' realms of cause and effect? Throughout its history the presentation of external causal forces, be they natural disasters such as floods, earthquakes, mutated monstrous creatures, giant meteorites or aliens, or be they societal forces such as institutions, revolutions, wars or economic depression, are invariably depicted as pre-personal catalysts or precursors to the actual development of the action proper. As David Bordwell has argued, the actual narrative almost always focuses upon the individual personal psychology of causes when it comes to constructing the action events of a film, i.e. the individual decisions, choices, the inherent strengths and flaws of character as well as the moral position being occupied (i.e. 'good' or 'evil'). Given the fundamental role that individual character-istics play within the overall narrative momentum of classical Hollywood cinema, one can recognise an irreducible element in the specific desire(s) manifested.

A character is often defined by what they desire most. This foundational desire establishes a goal of some kind. The process of achieving this goal is often the subject of the unfolding narrative of the film. This is a fundamental cornerstone of classical Hollywood film, yet if it were the only aspect present within the narrative there would be nothing to stop a character from consummating their desire immediately: man desires woman – man obtains woman; man wants to rob a bank to become rich – man robs a bank and becomes rich, etc. It is obvious that such a form would lack a certain something in terms of tension, suspense and excitement. Consequently, classical Hollywood film always elaborates a counterforce to one form of emergent desire; more often than not there is a conflict of desires its heart. An individual character confronts another whose desire is either fundamentally opposed to their own, or perhaps shares their desire for a specific object. Such conflict sets up a scenario where the individual protagonist needs to engage in some variety of action in order to resolve it and achieve their desire. A paradigm example would be the conflicted character of Rick, played by Humphrey Bogart, in Michal Curtiz's classic 1942 Hollywood film *Casablanca*. Torn as he is between his grief and bitterness at being abandoned by Ilsa, played by Ingrid Bergman, during the fall of Paris to the Nazis, his jealousy at her relationship with the Czech resistance leader Victor Laszlo when she turns up years later at his bar in Casablanca, and his enduring love for her, Rick struggles to do the right thing in helping the pair escape Casablanca and the clutches of the Gestapo. He holds the key to their escape in the form of counterfeit transit papers, which he could either sell to Ilsa and Laszlo for a small fortune (money neither of them have), betray Laszlo to the Gestapo and use the papers to accompany Ilsa from Casablanca, or sacrifice his love for Ilsa and give away the papers to them for both the nobility of love and the cause of resistance.

To engage in action in order to effect some change in a given

scenario and achieve one's desire demands an engagement with normal causal chains. Crucially, the types of cause and effect actions within which characters such as Rick become enmeshed must be transparent and recognisable to the audience. In a classical Hollywood narrative such as *Casablanca* the associative chain of causes that emerge from individual protagonists' desires tend to result straightforwardly in the effects of key narrative events. The way space and time are constructed by such films is almost entirely the result of being subordinated to such narrative causal chains. A film's plot routinely omits very significant amounts of time, i.e. the full duration of getting from location A to location B, in order to show only events of causal significance. In *Casablanca* the distance between the events in Paris and those in Casablanca are figured through a flashback. The narrative plot of these films always structure the story in such a way as to present the associative causal chain in the clearest and most coherent way to audiences. Individual psychological motivations in these films always strive to be as clear as possible. In other words, the narrative appears objective; an objective narrative reality is presented as a transparent organic background against which the various individual struggles of protagonists, who express varieties of perceptual 'subjectivity', can be measured. This organic objectivity is one of the keys to the universal appeal of this type of cinema, the other being the recognisable psychology and actions of the individual causal agents that people these films. The classical Hollywood schema (the Hollywood dream) presents individual human actions such as those displayed by Rick in *Casablanca*, situated in organic representation, as extending themselves towards the hope of achieving new desires and establishing a new moral world.

In its classical mode, Hollywood has always offered us the indulgent and increasingly banal lure of realistic fantasy. As Gilles Deleuze has noted, it was initially an emancipatory art form concerned with notions of individual and social transfor-

mation. There are countless examples within its history of films which repeatedly tell varieties of the same story – the myth of the human protagonist undergoing a fantasmagoric moral epiphany and transformation. Hollywood films operate on the basis of common sense, that we all know and can easily identify the morally corrupt and irrevocably compromised elements of the world around us. According to Hollywood we all know that certain social institutions are corrupt, evil and unjust. We can easily identify not just specific characters that are morally compromised, but we are also able to recognise specific character traits that have a devastatingly corrupt effect. It also assumes that we all share an implicit understanding of the solution. One could cite an enormous list of examples ranging from *Mr Smith Goes to Washington*, *Mr Deeds Goes to Town*, *Twelve Angry Men*, *Jerry Maguire*, *Kramer versus Kramer*, *Disclosure*, *Philadelphia* and *Regarding Henry*.

Let's look at *Regarding Henry*. Directed by Mike Nichols in 1991, this film tells the story of a successful New York lawyer, Henry Turner (played by Harrison Ford), and his struggle to both regain his memory and recover his speech and mobility after he survives a shooting. Prior to the shooting Henry is depicted as an ambitious, callous, selfish, narcissistic and immoral lawyer. The film establishes all of this by drawing upon clear and recognisable traits which we, as the audience, can easily comprehend. He is shown successfully and deviously defending a hospital in a malpractice suit against an elderly plaintiff who claims, but is unable to prove (since the hospital is suppressing the evidence), that he warned the hospital of a problem. Within this scenario there are a number of unambiguous clues as to Henry's obvious moral bankruptcy. In court he is shown to be arrogant, indifferent to the plaintiff's suffering, and unambiguously smug upon winning a clearly immoral case at their expense. One evening after work Henry goes out to buy some cigarettes at a local convenience store, interrupts a robbery and is shot. One of the bullets

hits him in the head, damaging his frontal lobe (which is the part of the brain that controls behaviour and restraint), and another hits him in the chest causing internal bleeding and cardiac arrest. Henry experiences anoxia, a lack of oxygen to the brain, and is left with brain damage. He survives the shooting but cannot move or talk, and he suffers retrograde amnesia. Now hospitalised, Henry, with the help of his African-American physical therapist, Bradley, slowly regains his movement and speech. When he is reluctantly discharged from hospital Henry returns to his family as a childlike innocent, unrecognisable from the person he had once been. He engages the doorman and the maid in conversation, where before he had barely noticed their existence. He is shown forging a new and revitalised relationship with his wife and daughter. However, at work in the law firm he is met with a mixture of pity, understanding, disdain and eventually impatient contempt. He discovers that his previous self was engaged in a series of infidelities. Through all of this Henry is brought to the realisation that he had been wholly unscrupulous. He wants to become a different person and to be fully reconnected with his family. He turns over the suppressed documents from the medical malpractice suit to the elderly plaintiff, resigns from the law firm, removes his daughter from her elite yet sterile school where she is deeply unhappy, and sets off for a new, more modest and recognisably good life with his family.

This film is a paradigmatic example of the Hollywood myth. It suggests that what is required for moral renewal is a cerebral trauma of such magnitude that one not only no longer recognises who one was before, but one also fails to recognise oneself reflected within the social roles and institutions one had previously occupied. Rather, one is cast out to the extent that one is able to re-assess one's entire identity, moral landscape and connection to the things around (i.e. family, class, race) at an absolutely fundamental level. Cognitive trauma provides the

type of shock in which one is able to break free from morally compromised ways of living, working and being unto others that one habitually occupied, and initiates a radical process of renewal. Is this not the 'shock from the outside' that is necessary to reawaken the person you really are so that you can begin to become the person you are supposed to be? Henry no longer remembers the cynical, work-obsessed, morally suspect lawyer he once was; rather, he remembers (ostensibly through his moral and existential rehabilitation at the hands of his occupational therapist Bradley, who it is revealed later in the film also underwent a significant existential upheaval through the imposition of personal trauma) who he should become. Henry is able to reconnect to his real feelings again – he is shown as desiring to be compassionate, caring, egalitarian, with an implicit sense of justice and fairness – an 'innocent abroad'. Henry's reintroduction to his family and to society is quasi-Franciscan. His vulnerability elicits kindness, compassion and ethical sincerity from those around him (even amongst some of his cynical lawyer colleagues). One might think of countless other examples which exhibit the same features as *Regarding Henry*, films such as *It's a Wonderful Life*, *Mr Smith Goes to Washington*, *Trading Places*, and *Forrest Gump*. The overall theme of these films is the notion of trauma as moral revelation and ethical re-evaluation –– in ways that are completely recognisable to us.

Classic Hollywood films function through psychological, behavioural and moral norms. They allow for easy identification by an audience. They activate cognitive norms, associative patterns of thinking and behaving, and recognisable forms of identity and interpersonal relations. They solicit a desire for narrative coherence in reality – closure, pattern, symmetry, synchronicity and significance. However, in doing this they are able to craft myths, fantasies and illusions concerning transformation, identity and social relations. Often the result is the mere reproduction of prevalent ideology, rather than resistance or

rejection. This reproduction occurs primarily at the formal level. These types of operative assumptions govern the way films are constructed, assembled and edited.

Within classic Hollywood cinema we can identify a narrative form best described as organic, with an inbuilt, almost transcendent presumption of the natural truth of such a form. The agents in these films want to 'correct' life by making it conform to an atemporal, systematic and transcendent image of truth that matches their 'good' desires. In this approach, judgements require a transcendent system that protects thought from error by isolating or extrapolating it from life. Classic organic cinema projects, through rational divisions of cause and effect, a notion of truth in relation to totality. Its pre-given affinity to extraneous images of truth is an attempt to encompass and subsume the world as image and to make life conform to the laws of an ideal world, one that overcomes and transcends life and against which life must be judged. Organic representation brings with it a sense of transparent intelligibility, coherence, perfect vision and an idealisation of the real.

Part of what makes classic continuity film appear invisible and, to some extent, natural, is its developed ability to draw upon a range of cognitive skills we have acquired for negotiating the everyday world and that are so familiar that they appear entirely automatic. Continuity editing is a powerful tool for reinforcing our cognitive and perceptual habits, rendering film as an organic naturalistic phenomenon. The continuity narrative form is synonymous with classic Hollywood cinema simply because this form, which assumed its rudimentary shape in the early days of Hollywood studio cinema, has, and continues to have, a powerful influence on the entire historical development of film form. The Hollywood film world is marked by a high level of internal consistency where events appear to not be constructed for filmic purposes but as a pre-existing and tangible story-world that is framed and recorded from without. Such

classical film narration usually involves the concealment of the means of production and creates an illusion of the passive, invisible and outsider observer who is watching a spectacle that appears not to have been artificially constructed but that pre-exists its formal and narrative representation in film. Hence, the ongoing significance of having a recognisable filmic milieu. The form that the action of the narrative takes for the spectator can be considered as a carefully constructed analogue of their natural psychology. Since the 1930s the practical and technical devices which are employed by Hollywood have become organised into a highly stable and robust paradigm, and, like all paradigms, have a tendency to become naturalised as *the truth*, or as reality itself. The stylistic conventions associated with this classical paradigm have become immediately and intuitively recognisable to most audiences. Within the dominant Hollywood tradition there is a continued obedience to a set of highly developed extrinsic norms which govern the formal construction of most films. The principal innovations, to the extent to which they exist, occur almost completely at the level of content, in terms of the stories which films tell within certain established genres, rather than form.

Consider the conventional art of cinematic realism in terms of its sequencing and narration. According to cognitive approaches, typical cinematic form engages important aspects of our perceptual apparatus and cognitive associations that are already established for processing our understanding of the reality in which we function. The same cognitive architecture is activated by cinema as by everyday reality, and just as our abiding cognitive concern is with a search for coherent sense, the same goes for our relationship with film. According to such a view cinematic sequences are constructed through a variety of formal means for exploiting our 'natural' cognitive and perceptual dispositions. One of the most prominent advocates of this view of film is the American film philosopher Noël Carroll, who deploys

a cognitive schema to comprehend the norms governing film perception and cognition. Carroll's approach identifies three major formal components that are utilised by film for successfully influencing and directing the audience's attention – 'indexing', 'bracketing' and 'scaling'.[4]

Indexing occurs when the camera isolates filmic attention on a specific subject through movement, cut or zoom. In order to better understand this classic technique it is worth considering a number of sequences from Hitchcock's *Vertigo*. When the retired detective character of Scottie, played by James Stewart, is employed by an old college friend to trail his wife Madeleine, played by Kim Novak, the friend invites him to observe them at dinner at a restaurant called Ernie's so that he can subsequently recognise her. In this sequence we move slowly from a close-up of Scottie sat at the bar to a wide shot of the entire restaurant before focusing upon the table where his friend and Madeleine are sitting. As they leave the restaurant Madeleine walks past Scottie and Hitchcock uses an indexical technique to isolate Madeleine's face in profile for Scottie. This technique for isolating this character's profile is used again later in the film when a now grief-stricken Scottie spots a girl in the street who resembles the dead Madeleine. The technique is notably used again in the film when Scottie and Madeleine visit the Spanish Mission to recover the past which seems to be haunting Madeleine. Standing outside the Mission's chapel Madeleine insists on going in alone, and as she breaks from Scottie's embrace she stops and stares up at the chapel's tower before running into the chapel. We cut to an indexical shot of this tower. We then cut back to Scottie who sees her glance upwards and looks there himself. We cut back to another indexical shot of the tower and then back to a close-up of Scottie's face as he realises, too late, her suicidal intentions. Both of these indexical shots of the tower serve to clarify the narrative intention of the sequence, allowing the audience to identify with the thoughts and actions

of the characters onscreen. The final example of indexing is in fact the key to Scottie's unlocking of the elaborate criminal conspiracy within which he has become enmeshed, and concerns the instance of Carlotta Valdes' necklace. Towards the end of the film when the grief-stricken Scottie has made over the character of Judy to resemble the dead figure of Madeleine he recognises the necklace that Judy asks him to put on her as having once belonged to Madeleine. As he recognises the necklace around Judy's neck Hitchcock provides a series of indexical flashback shots of the necklace appearing in the portrait of Carlotta Valdes, around Madeleine's neck and then around Judy's neck. It is the necklace which allows him to realise the truth that Judy and Madeleine are in fact one person, and that he has been hoodwinked all along by an elaborate criminal conspiracy perpetrated by his old college friend to murder his wife. Carroll insists that this process of perceptual isolation and focus emulates the way our perceptual system actually functions in the everyday world, and is a powerful means for simulating the way our perceptual system is composed of successive shifts of attention that appear automatic and natural.

Another simple example of the way films achieve this can be seen in the way they typically construct a conversation between two characters. Rather than place the camera at a fixed position where we might passively observe both characters simultaneously, conventional film utilises indexing to alternate between the interlocutors as their dialogue unfolds. The result is an active visual dynamic that closely emulates the indexical activity of our normal perception. Filmic indexing has created a flow of images that capture what Carroll regards as the natural essence of human perception. Another simple and common use of indexing for conventional narrative purposes in film involves the isolation of significant objects. A character under threat desperately searches around the room for a weapon to defend themselves with, and suddenly they spot a gun on the desk. The convention

typically prescribes an indexical marking of this perception with an isolated shot of the gun on the desk. Or, perhaps a telephone rings during a sequence, attracting the attention of a character, and we get an indexical close-up of the telephone. The character's isolated perception of this object is emulated for us through a rapid moment of visual indexing, and more often than not this has the seamless appearance of according with the natural flow of our own perceptual expectations and habits. Although highly stylised and artificial, demanding a high level of technical innovation and post-production, indexing has emerged as a very successful means for ensuring the smooth and seemingly natural flow of images.

In addition to the techniques developed with regards to indexing, the cinema is also able to direct our attention by bracketing what it is that we are seeing on screen at any given point in time. By choosing to focus attention on specific objects, characters or events, the camera is able to edit out everything that is beyond the natural perimeter of the frame. Take, for example, the opening scene of Quentin Tarantino's *Pulp Fiction*, which depicts a conversation in a booth at a diner between two characters (played by Tim Roth and Amanda Plummer). For the purposes of this sequence the booth is bracketed off from the rest of the diner (which is, at this point, not narratively significant). Our attention is focussed entirely upon the two interlocutors. Later, as the film unfolds and the characters initiate a heist, the bracketing is loosened so that our attention becomes diverted away from the booth onto the diner as a whole. Bracketing provides an effective and flexible means for directing perceptual attention in film, and has become one of the cornerstones of classical narrative filmmaking. However, in addition to its role in directing perception, it has also become an effective means for implying exteriority and ontological continuity, thereby becoming part of the way film attains a sense of realism. The danger of artificially bracketing off a specific milieu is that one

might easily isolate and hermetically separate a particular scene from its continuity with the outside world. This creates a perceptual disturbance and disrupts the spectator's overall expectation of filmic realism. However, techniques have emerged to ensure that bracketing continues to imply exteriority and continuity. Two examples which demonstrate this, both taken from Alfred Hitchcock, are found in the bracketed apartment set of *Rope* and the rear of the apartment block in *Rear Window*. In both films the bracketing of a specific milieu is absolutely crucial to the success of the subsequent action. Yet with both films Hitchcock devised innovative ways to imply ontological exteriority and continuity. In *Rope* this is achieved by the shifts in light across the cityscape of the apartment window, together with occasional external sounds. In *Rear Window* there is an alley between apartment buildings which leads to a busy city street. Here Hitchcock allows us a limited and subtle view onto an imaginary external world (outside of the main filmic milieu of the apartment buildings themselves), which is indicated by passing traffic and pedestrians.

Bracketing has become one of the most powerful orthodox techniques for isolating perceptual activity to a specific milieu, set of characters and objects. By utilising this technique the filmmaker is able to indicate to the audience what is important at specific moments during the film. Everything outside the frame has been bracketed from the audience's attention, thereby emulating the seemingly natural perceptual process associated with the everyday. But it has also been harnessed to augment the overall sense of film realism by implying the ontological continuity of the bracketed filmic elements with the everyday world we all inhabit. The ontological continuum constructed by ordinary perception, where our ordinary isolated perceptions are incorporated into a totality, is emulated to some degree by cinema.

In addition to arguing that indexing and bracketing

developed to control attention by isolating certain details over others, Carroll identifies the way that film manipulates the scale of what an audience is looking at. Through scaling the director is able to fill the audience's awareness with whatever they deem necessary and appropriate. Consider, for example, Sergio Leone's famous technique of extreme facial close-ups in films such as *Once Upon a Time in the West* where the screen is filled with close-ups of character's eyes during tense gunfights. Scaling also enables the filmmaker to render what is less narratively significant much smaller and, as a result, a less likely object of audience attention.

One of Carroll's most important insights is that the coordination of these visual techniques render most typical and conventional films, as they unfold from shot to shot, as not only easy to follow but as being structured in an entirely natural way and entirely in accordance with normal perception. Thus, the highly structured, dynamic and stylised film schema has the tendency to be a passive perceptual experience insofar as it naturally accords with our perceptual habits. This emulation of normal perceptual processes is also extended into cognitive associations. It is not merely a question of establishing a naturalistic perceptual trajectory but also an inferential and associative chain of cognition. Film emulates the tendency of natural cognition to be guided by inductive force. Most typical cinema will contain visual aspects where the inferential linkage is unavoidable and inevitable (i.e. passive induction), yet most will rely, to some extent, upon the viewer to actively arrive at an inferential hypothesis that consummates the sense a filmmaker intends to convey. There is a certain degree of autonomous cognitive activity being solicited by conventional films, which is often regarded as one of the major pleasures associated with film spectatorship. Hitchcock is often regarded as a master of this particular technique, emulating and manipulating the thought of the audience to a remarkably high degree. In fact, Deleuze

referred to Hitchcock's cinema as the consummate cinema of the mental-image of consciousness.[5] Filmmakers, Carroll argues, rely almost entirely upon established inferential associations and interpretational processes that we use to negotiate everyday reality. In order to successfully cognise a film narrative the operative assumption is that we utilise exactly the same kinds of beliefs, associations and inferential strategies that we normally employ with regards to the everyday. This is Carroll's second crucial insight; it is not necessary to internalise a specific semiotic in order to comprehend film narrative. Rather, most typical films can be approached in terms of ordinary and established patterns of reasoning and the employment of familiar and existing beliefs regarding human behaviour, motivation and action. This can still, however, be understood as a somewhat active process.

Carroll's view of normal film perception and cognition restricts film ontology to a narrow and restricted realm (i.e. as an analogue of the established familiar everyday), even within films that are presenting a fantasmagoric realm. Films which formally deviate from what he regards as typical are almost always consigned to being interpreted from within the established and orthodox paradigm, thereby enabling him to categorise their aberrance and deviation from the norm as being almost entirely driven by a desire 'to lay bare reflexively the structures that make the normal narrative motion picture experience what it is.'[6] Whilst Carroll has no argument against this particular function, he appears incapable of assigning to any film which deviates from the norm any other orientation than the normative. Those films which deviate from the norm are consigned to that class of films which either form a reactionary impulse against the orthodox, or are concerned merely with reflexively exposing the mechanics which underpin that orthodoxy. This class of film, for Carroll, is almost entirely meta-cinematic – i.e. being merely films about films.

A film as rich, puzzling and paradoxical as Alain Resnais' *Last*

Year in Marienbad (1961) is reduced to being about the frustration of our ordinary narrative expectations, in the way that it refuses to offer us not only the natural inferential associations at both perceptual and cognitive level, but also in terms of its narrative structure (or lack of one). Resnais' film, set in a chateau at Marienbad, tells the story of a man who approaches a woman claiming to have met and had a relationship with her the previous year, yet she claims never to have met him before. It proceeds through a series of ambiguous flashbacks and extremely disorientating temporal and spatial shifts. In this highly original way the film provides a fascinating exploration of the relationships between the different characters, constantly questioning the status of reality, memory and fantasy. Conversations and events are repeated in several places in the chateau and grounds, and there are numerous tracking shots of the chateau's corridors, with ambiguous voiceovers. However, Carroll consigns the film to being reactionary, anchored in a revolt against existing cinematic convention. All of these things may in fact be true but for Carroll they are not simply true but express pretty much everything there is to know and say about this enigmatic film. The film exists to bring us to a state of awareness regarding the way in which our established (and usually implicit) expectations assist us in following and organising films as they unfold, simply through the fact that these expectations are consistently frustrated and perverted. Such films as this do not elaborate either a separate and autonomous semiotic or alternative filmic reality since all they do, according to Carroll, is playfully subvert our given perceptual and cognitive apparatus. The effect of this is to provide an acute sense of awareness with regard to these faculties which are all too often hidden, implicit and automatic.

By drawing upon Carroll's cognitivist paradigm, the American film theorist David Bordwell has also produced some interesting work on film cognition and comprehension. Bordwell

argues that comprehending a film is always a constructive activity on the part of the spectator, 'spectators participate in a complex process of actively elaborating what the film sets forth'[7]. He acknowledges Carroll's point that such a process draws upon ordinary and everyday reasoning where one draws upon prior knowledge, makes informal and provisional inferences and, based upon the presence of inductive force, hypothesises as to what is likely to happen next. It is thus a matter of coming to understand the way in which films are deliberately designed to elicit the sorts of cognition that result in comprehension. In his recent work, Bordwell has focussed on seeing films as 'norm-driven' systems for providing spectators with clear cognitive cues. Such cues initiate a process of cognitive activity and elaboration, resulting in an ongoing process of inferential associations and hypotheses. The spectator always brings to the various cues that are presented within a film certain established knowledge which enables them to extrapolate and speculate beyond the specific information given in the cue. Similarly, there is an assumption that the spectator possesses some basic understanding of narrative structure which allows for some information to be taken for granted and other information to be understood as crucial exposition or as an important revelation. For Bordwell the film gains its effects 'only in relation to a body of norms, sets of schemata, and the processes which the spectator initiates.'[8] His active and constructive model of film comprehension, which relies upon the presence of certain knowledge, norms and schemata, does at least allow for the possibility that a spectator could go beyond the basic information supported by a film in order to arrive at their own interpretation. As Bordwell claims, 'what makes a film understandable is not necessarily exhausted by what the filmmakers deliberately put in to be understood.'[9]

Bordwell insists that the cognitive operation undertaken by the audiences of classic Hollywood cinema are not entirely

passive despite drawing largely upon the habitual and the familiar. However, he acknowledges that such audiences have their cognitive processes activated, manipulated and controlled in a very strict and absolute way. Classical narration demands that the spectator actively constructs the stylistic features being presented in a single way – what both Carroll and Bordwell regard as the 'natural' way. For example, one could not reasonably claim to reach the end of Capra's *It's a Wonderful Life* and still have reached the conclusion that George Bailey (played by James Stewart) would still be better off dead. With Capra's film there is a single truth to be arrived at. The spectator actively constructs form and meaning to a certain established and orthodox process of knowledge, memory and inference. Successful narrative films function by providing the spectator with a series of inputs that are needed to undertake the coherent associative chain of inferences and establish story. As we have already indicated, this is augmented through the formal techniques developed within cinema for managing perception (i.e. managing the flow of perceptual attention). This allows both Carroll and Bordwell to conclude that most typical films are accessible simply because they so effectively employ our natural perceptual and cognitive capacities. The ontology of film is entirely analogous with the reality established by everyday perception and cognition operating in the everyday – the reality of film is an analogy of everyday reality.

Alongside Carroll's claims regarding the derivative nature of aberrant forms of cinema (discontinuous forms of cinema such as Resnais' *Last Year in Marienbad*), Bordwell claims that alternative forms of cinema always mobilise, echo or trace classical narrative form in order to solicit different forms of perception and cognition. For both of these thinkers, in an unsustainably reductionist move, alternative cinematic forms are always subordinated to the pre-existing norms associated with the classical paradigm. The way in which both theorists anchor film

perception and cognition so closely to the orthodox paradigm means that something essential regarding cinema risks being lost. They refuse to consider film outside of its most conventional paradigm and to consider the possibility that film has the capacity to construct an entirely separate and alternative semiotic, sense, ontology and epistemology. Against this, I will argue that film must be re-conceived in opposition to this view, and claim that film has a range of intrinsic (albeit all-too-often underemployed) capacities for vertiginous affectivity, alternative realities and mystery which go beyond orthodox modes of perception and comprehension. Indeed, film can reveal what it is that common sense conceals when its form becomes detached from common sense.

Common-Sense versus Counter-Sense

All films require, to a certain extent, the activation of everyday common sense. This allows us to form associations, hypotheses, and assumptions, to enact judgments and affective responses. All of these suggest a degree of activity on the part of the spectator. However, film should not be restricted to the reproduction and formal expression of normal perception and cognition. Such a view operates first and foremost on an impoverished assumption regarding the nature of what cognition is in totality, rather than seeing film as reproducing one mode of cognition amongst many. It also neglects the fact that film itself plays a role in the construction of this particular mode of thought. It rests on the view that the majority of narrative film is so successful simply because it adheres to the 'natural' order of human cognition. This view of cognition is underpinned by both naturalism and essentialism.

By only ever appealing to the most generic, habitual and familiar ways of thinking, behaving, and being affected, too many films result in the mere activation of the small 'I', the self that one already is. The activation of the larger 'I', the self that

one might yet become, requires an unfamiliar counter-sense, a trauma associated with formal and structural innovation, challenges to narrative norms and associations which are uncomfortable, troubling, and disturbing. This involves concentration, learning to see things in new ways, a willingness to open oneself up to the new and to the different, and discovering new levels of the self, new forms of emotional, cognitive, visceral affectivity, new understandings of the self and its relation to others and the world.

All forms of society embrace a general politics of truth which is manifested or expressed through a number of different mechanisms, including certain forms of discourse that are accepted as 'truth', or that appear 'naturalised', at any given time within society. These forms of discourse, which include cinema, essentially come to govern the way that anything can be meaningfully represented, thought or discussed. The politics of truth at any given point becomes so naturalised and all pervasive that it is increasingly difficult to imagine how to think, act and feel in any other way. Despite the appearance of naturalism, the forms of our discourse are never something neutral and value-free, but are something always shaped by the current dominant discourses which in turn shape how we think and act. These regimes of truth and realism effectively construct, rather than represent or describe, our world. In doing so they exercise a form of control and power that becomes invisible in proportion to their apparent neutrality and naturalism. These forms of discourse transmit and produce power and as such are important instruments of power. They shape and direct our ways of looking at and understanding the world, and the way in which certain views become naturalised forms of convention and therefore considered as real. They govern our thoughts and actions towards what is perceived as the 'correct', 'normal, 'real' and 'desirable' way of being within society, or in other words, our implicit sense of realism. The dominant forms of discourse

become a restrictive framework bounding and shaping our thoughts, actions and aspirations, and act to regulate social understanding, action and political formation.

As Foucault recognised, such disciplinary forms of power are both pervasive and invisible, and are 'tolerable only on condition that it masks a substantial part of itself. Its success is proportional to its ability to hide its own mechanisms.'[10] They force us into a normalised way of seeing the reality of the world and thus sanction our behaviour and thoughts towards a given and natural form of truth. In this way we govern our own thinking towards what, within the dominant discourse, is viewed as the correct way of being, way of thinking or way of acting. We conform to an established normalised goal and reality to such an extent that any behaviour or ways of thinking which fall outside of this norm are demonised, ridiculed and ostracised.

All too often the cinema of counter-sense, as opposed to that of common sense, is just seen as the province of art cinema rather than an important element of popular mass culture. This distinction has become normalised, and it seems that it just is the case that difficult and challenging ideas, expressed in unfamiliar and challenging ways, will not have a mass audience. The assumption appears to be that mass audiences merely want the reproduction of familiar forms, activating and reinforcing the familiar small 'I'. This is a pernicious and dangerous cultural assumption which ignores the extent to which any new and innovative form (particularly in the cinema) contains its own pedagogy of seeing, interpreting and understanding. The naturalised (and patronising) assumption that mass audiences lack the capacity to engage with an object's (i.e. a film's) implicit pedagogy is extremely restrictive and elitist. It suggests a sinister assumption regarding our capacity to activate and cultivate a larger self, by closing down any possible notion of a self other than what one already is.

Consider the case of Christopher Nolan's 2010 film *Inception*.

The film is ostensibly a Borgesian science-fiction heist movie. The conceit is that a group of characters have devised a means to perform illegal corporate espionage by entering the subconscious minds of their targets, using multi-level 'dream within dream' strategies to extract valuable commercial information. They are approached and asked to perform an act of 'inception', the planting of an idea within a person's subconscious mind, in this case for commercial gain. The team successfully create a complex dream architecture and enter into the mind of the target subject, engaging in an intricate set of actions in order to effect inception. Many reports of this film regarded it as unfeasibly complex, challenging, confusing and difficult to understand. However, despite its obvious ambition and highly accomplished production values, it is in fact a straightforward film in terms of its structure, form and comprehensibility, adhering to the recognisable qualities associated with the action-thriller genre. Indeed, *Inception* might well be fruitfully compared with Nolan's earlier breakthrough film *Memento*, a film which upon release garnered a similar set of critical responses. *Memento* tells the story of a man with anterograde amnesia, which renders his brain unable to store new memories, and his efforts to track down the man who had attacked him and his wife (leaving his wife dead and him unconscious). The film consists of two distinct and intercut sequences – those shot in black-and-white (which are chronological) and those in colour (which are shown in reverse order). The two sequences coincide with each other at the climax of the film, producing one coherent story. Both of these films appear irretrievably fractured, complex and counter-intuitive, but on closer inspection are revealed to be novel and original variations of orthodox filmic narration. Both adhere to the conventions associated with their respective genres, *Memento* with the crime-thriller genre, *Inception* with the heist/espionage genre.

What Nolan manages to achieve is a modicum of audience

disorientation through careful interventions into the way we might normally expect to perceive and cognise films, yet this disorientation is never really at the expense of orthodox action narrative but is only a means of further enhancing and energising the form. Both *Memento* and *Inception* adhere to the dominant norms of perception and cognition at play in the construction of classical action narrative, and indeed the solicitation of both is absolutely vital to the overall success of these films as action thrillers. The mere existence of narrative disorientation in either of these films should leave us in no doubt that any radical cognitive disruption and affective dissonance is entirely absent. These are films which are as commercial as they are classically orthodox.

Within *Inception* there is not only a pitiless banality to the tone of the dreams presented but their construction across different levels relies entirely upon normative inferential relationships as opposed to aberrant, deviant and weird ones. Nolan's conceit throughout the film is that a strictly quantitative relationship exists between the different levels of dreams which accounts for the qualitative differences in the way time is perceived within each. The existence of such a quantitative formula reveals the degree to which the action, in a film which purports to be about the fragmented and fantasmagoric realm of dreams, is actually presenting a well-defined, organic and almost corporate unity of sense which is never actually disturbed from start to finish. There is a malignant logic of exponential addition at play here that robs the depictions of the so-called dream states of any semblance of affective enigma. As the theorist Jean Baudrillard recognised in his writing on contemporary cinema:

Everything seems programmed to disillusion the spectator, who has no other alternative than to witness this excess of cinema bringing the illusion of cinema to an end ... Cinema today knows neither allusion nor illusion: it links everything

on a hypertechnical, hyperefficient, hypervisible level. No blanks, no gaps, no ellipses, no silence … It is always by adding to the real, by adding real to real in order to create the perfect illusion (the illusion of resemblance, the realist stereotype) that illusion is thoroughly killed. We have not stopped accumulating, adding, raising the stakes. And because we are no longer capable of confronting the symbolic mastery of absence, we are now plunged in the opposite illusion, the disenchanted illusion of profusion, the modern illusion of the proliferation of screens and images.[11]

The main action sequences accompanying the inception mission consists of a tableau of a dream within a dream which is itself within another dream. The strict quantitative relationship between the dream levels, played out as three simultaneous action sequences occupying three distinct temporalities, exists almost exclusively for common-sense narrative purposes. The film contains little more than a series of strong audience clues for assembling 'sense' through orthodox inferential hypotheses. Moreover the subsequent 'sense' which emerges is not only remarkably straightforward but downright banal. The act of inception is presented in remarkably quotidian terms, consisting of the most clichéd reconfiguration of a character's relationship to his dying father, i.e. namely the revelation that his father really did love him, and his only disappointment with regard to his father was that he wanted to be more like him. The newfound confidence in his father's love and the apparent belief in himself as an autonomous person is supposed to lead him to make a subsequent corporate decision, following the death of his father, to break up the business, to the obvious advantage of a business rival who commissions the act of inception in the first place.

Another example of conventional genre cliché at the heart of this film is contained in the defining characteristics of the man who leads the team responsible for the inception (played by

Leonardo DiCaprio). He is presented through the dreadfully familiar tropes of the tortured and troubled figure struggling with a dark secret in his past – he is haunted by the guilt surrounding the suicide of his wife as a result of his previous attempt at inception. To help her escape from limbo during a shared dream experience, he planted in her the idea that her present world wasn't real and that she needed to deliberately kill herself to wake up from it. However, once she had returned to reality, she became utterly convinced that she was still dreaming and still needed to die in order to wake up, hence her act of suicide which results in her real death. Although, there is every possibility that it is the prospect of marital tedium in reality that leads her to knowingly commit suicide for real. Because of his guilt she continues to appear as a violent and disruptive figure in his dream missions, and the character is shown as making repeated journeys into his subconscious to visit the figure of his dead wife to become reconciled with her. This has all the originality of the archetypal cop with a drink problem and a difficult marriage, repeatedly depicted in Hollywood films and TV cop shows.

The presentation of fantasmagoric dream spaces in Nolan's film is subordinate to the reduplication of a banal architecture of surfaces which engage the audience's normal of patterns of perception and cognition. This is the cancer of contemporary cinema: the excess of technical virtuosity, special effects, egoistic clichés and superficial tedium. Indeed, what is so striking about *Inception,* what is truly disturbing about it, is the fact that audiences have felt so challenged and confused by it at all. It is, after all, simply a manipulation of orthodox form in order to render that form with the sheen of novelty and originality. It is the banality of the same presented as something different, alternative and new. This is a film that appears to require the most modest level of spectator participation in the active construction of sense as the film unfolds, yet apparently even this has a

tendency to divide, confuse, perplex, enrage and deter audiences. Why is this? What does this reveal about the contemporary cinema audience? What does this say about what has happened to our minds under capitalism?

It is worth considering what *Inception* actually has to say about the role of inferences and causation. It is concerned with the attempt to deliberately plant inferential cues in the subconscious dreaming mind of an individual. This is undertaken in order to provoke what appears to be autonomous patterns of thought on the part of the dreaming subject. Is this not how advertising and marketing operate under capitalism? The dream architecture is orthodox and unimaginative, constructed entirely according to the restricted realms of unimaginative capitalist realism (it is as if surrealism never happened) – it is composed of consistent surfaces that mirror the everyday and is entirely subordinate to the established logic of the everyday real. Again, as Baudrillard recognised:

> The image can no longer imagine the real because it is the real; it can no longer transcend reality, transfigure it or dream it, since images are virtual reality.[12]

To achieve the internal consistency and autonomy of the alternative dream space it is necessary to use other means than the established orthodoxy of organic unity. It is necessary to construct substantive counter-sense. The dream space presented by film must be qualitatively set apart, it must have its own aberrant and subtractive logic, its own autonomous rhythm and pattern of thought. The films of David Lynch, for example, experiment in the baroque counter-sense of the dream, exercising a powerful affective hold and proffering genuine potential for cognitive transformation.

The limitations on experiments with filmic form in classical cinema present a real constraint upon any future developments

in our perceptual and affective capabilities, in our potential to become other than what we are. This can only continue to have a detrimental effect on our capacities to relate in new ways to ourselves, others and the world. In this sense there is a real link between orthodox popular film form and the present culture of nihilism. There is clearly the need for the cultivation of new forms, new images, new possibilities, new affective capacities, the construction of a new people 'to come', and the renewal of belief in order to restore a missing world. The cinema of counter-sense clearly has a capacity, as a mass art, to effect this type of change.

Discontinuity film has the capacity to confront us directly with counter-sense by constructing itself upon a radically non-chronological sense of time – a time without measure, a time that extends the perceptual limits of common-sense, which is capable of restoring the affective grandeur of the world. As Deleuze recognised, such a form of cinema is in fact closely linked to previous political projects in classical cinematic history, which includes the films of Eisenstein, Italian neo-realism, French New Wave and Classic Hollywood itself. What filmmakers across that history shared was a sense that what is outside of thought is our existential and ethical relationship to time as an infinite reservoir of non-determined choice. Thought must confront the as-yet-unthought. There is always an actual material state of affairs, but there is always a dimension of the future which remains open and undetermined. Choosing to choose becomes the deepest ethical problem, the problem of choosing a way of life defined by the possibility of choice. The constraints of established modes of perception and moralism must be overcome by choosing to believe in the possibility of perceiving otherwise and of recasting moral and political norms anew. The strange associative linkages in discontinuity film express the order of Pascalian 'choice' and the Kierkegaardian 'leap of faith', and begin to configure that open dimension of the future. Rather than the links formed by

repetition and habit in common sense, discontinuity linkages are productive rather than reproductive associations. They are capable of restoring a vision of a world to come, rather than endlessly reproducing the baleful one that already exists. There is the hope that the present may become altered through the presence of alternative visions of a hidden dimension of possibility. For Baudrillard it is a matter of cinema's power of utopian illusion:

> An image is precisely an abstraction of the world into two dimensions, removing a dimension from the real world and therefore inaugurating the power of illusion ... By removing a dimension from real objects their presence is rendered magical and dreams are restored, total unreality in its minute exactness ... This is what we have forgotten in modernity: subtraction brings force, power is born of absence.[13]

It is important to understand how certain forms of discontinuity cinema do not just operate as anchored against a background of normative cinema (they are not merely reactionary in the way Bordwell and Carroll suggest). Such a view robs them of their objective originality and autonomy as films developing something entirely new. Such a view consigns them either to the status of meta-films simply critiquing, challenging or opposing normative classical narratives in cinema) or to the status of anti-films. The first categorises them within the realm of films about film (i.e. modes of film perception), the second to an order of decontextualised anarchic experimentation that can only exist at the fringes of what could ever be considered coherent and integral cinema. This view robs certain modes of cinema of their challenging, autonomous and vital nature. Genuine cinema cannot reside in its perceived capacity to mechanically reflect the conditions of the world as it appears, but in what Baudrillard called its ability to summon an 'exacerbated illusion', and

become the world's 'hyperbolic mirror.'[14] The rest of this book will offer exemplars for the broad claim that cinema can, and must continue to have, a crucial role in the effort to resist the nihilism of the present by summoning new visions of the social, of thought and of the Earth.

Apocalypse, Counter-Sense and the 'People to Come'

'Carrying the Fire': Apocalypticism and Nihilism in the Contemporary Situation

You have to carry the fire.
I don't know how to.
Yes you do.
Is it real? The fire?
Yes it is.
Where is it? I don't know where it is.
Yes you do. It's inside you. It was always there. I can see it.
Cormac McCarthy, *The Road*

Dystopic visions abound in contemporary popular cinema. They include the apparent environmental catastrophes of *The Day After Tomorrow*, the cosmic disasters of *Deep Impact* and *Armageddon*, the mystical and religious annihilations of *2012* and *The Book of Eli*, the alien destructions of *Independence Day*, *War of the Worlds* and *Signs*, the technological blitzkrieg of the *Terminator* series, and the ineffable, ambiguous or unknown catastrophe of which *The Road* is the most recent example. Across most, if not all, of these films is a disturbing inability to imagine alternatives to the established order and temporality of the present. Most replicate familiar moral tropes along with a pessimism regarding new forms of collectivity and social organisation. Despite the paradoxical fact that many of these films display an innate sense that disaster is probably the result of capitalism's nihilistic drives, they do little to posit alternatives to what Mark Fisher has called 'capitalism's entropic, eternal present'. For this reason alone, most of these films are deeply

unimaginative and stupid.

The dystopic visions in many of these films replicate aspects of catastrophe present in the twentieth and early twenty-first century, be they environmental, political, technological or moral. Modernity's growing sense of crisis is reflected by this cinematic genre. This is coupled with an awareness that catastrophe is always something that has already happened – we are living amidst the ruins. Hence, the spectacle of global annihilation is itself a pretext for the exploration of the post-apocalyptic, of the space of time that is left over after the disaster that has happened. Is it possible that the concern with this post-apocalyptic space is the point at which these films address our current situation at its most acute? And is it possible that the impoverishment of their post-apocalyptic scenarios is one of the clearest and most acute evidence we have for the impoverished and nihilistic level of political and social thought at the beginning of the twenty-first century? Apocalyptic and post-apocalyptic cinema presents us with a pernicious form of temporal stasis, itself a symptom of current nihilism, where we are thinking, acting and being within and upon the basis of established common-sense. Such thinking remains anchored to an increasingly reduced, restricted and flattened realm of actuality. The reality we are shown to be thinking from is a destroyed and ruined one, detached from the time of history and from the open space of future alternative possibility. The typical cinematic vision of the apocalyptic and post-apocalyptic merely serves to reinforce the inevitable and monolithic quality of current social reality, a nihilistic present dominated entirely by the ceaselessly repetitive logic of capital. Whether the scenarios presented are religious or secular, most of the popular visions of the end of days, and its aftermath, repeatedly emphasize the fact that radical collective and social reform are definitely not the cure to what ails us. They repeatedly and obsessively posit the idea that the answer lies within a lone individual pursuit of a re-established level of moral integrity

together with a renewal of the conventions associated with the atomic family. This is formulated most explicitly in Hillcoat's cinematic adaptation of Cormac McCarthy's novel *The Road*, where these ethical objectives are figured as a 'fire' being carried forward by a small select band of individuals and families despite the total conflagration that has overtaken the world and the descent of the rest of humanity into a terrifying Hobbesian state of amoral barbarism. The heart of a film like *The Road* is recognisable in most cinematic presentations of humanity in the apocalyptic and post-apocalyptic scenarios. It is as if the lone protagonists in these films are undergoing a savage flash of discontinuity where they are torn from their usual state of absorption within collective inertia. The morality kindled within the souls of these remarkable individuals is provoked by the violent dissolution of their shared habitual world and the shattering of their former identity with the collective (be that a national identity or a species identity). What is produced, once violently separated from their collective absorption, is a lone post-apocalyptic agent, a new existential hero carrying the flame of morality amongst the ruins. Such loners populate many of the cinematic presentations of apocalypse, from Charlton Heston's Robert Melville in *The Omega Man*, Tom Cruise's Ray Ferrier in *The War of the Worlds*, Mel Gibson's Graham Hess in *Signs*, and Viggo Mortensen's man in *The Road*.

As was discussed in the previous chapter, this narrative structure is familiar since it forms such a fundamental corner-stone of classical Hollywood film. As Bordwell has argued, narrative in these films almost always focuses upon the individual personal psychology of causes when it comes to constructing the action events of a film, i.e. the individual decisions, choices, the inherent strengths and flaws of character as well as the moral position being occupied ('good' or 'evil'). Most of these films are little more than spiritual allegories which aim to elevate and celebrate the common-sense clarity of

individual moral purpose in the face of mass nihilism, despair and barbarism. Such allegories are surely representative of little more than symptoms of accelerated capitalism which has almost completely eroded any sense of emancipatory collective endeavour. The abstracted individual is the only hope amidst the ruins; ruins, of course, of our own actual world and our own actual present. Nihilism, broadly defined as the conviction that nothing matters anymore and that nothing makes any difference to the existing state of affairs, is repeatedly presented by these films in the face of global catastrophe. They present a devastating form of a stasis in the current state of thought, with future possibilities for transformation trapped within the narrow parameters of the present. The ugly truth of this atemporal present is an inexorable growth towards a sense of numbness, detachment, and indifference to it. These are all symptoms of a contemporary nihilism that has epistemological as well as moral dimensions, implying a loss of belief in the very goal of social and collective transformation as something either achievable or intrinsically good. Through these films we are presented with worlds in which a belief in the positive nature of collectivity and transformative possibilities has been fatally eroded.

Apocalypse

The word 'apocalypse' (derived from the Greek word Apokálypsis) means the lifting of a veil or revelation, and signifies the disclosure of a truth previously hidden beneath a false appearance. The idea of an underlying true design and determination for the phenomena of history has traditionally characterised apocalyptic ideas.[1] In this sense they resemble the ancient idea of there being a divine fate determining all things in time. As the philosopher Martin Buber notes, in apocalyptic thought 'everything is predetermined, all human decisions are only sham decisions'[2]. By suggesting that all history is predetermined, apocalyptic belief systems affirm that nothing in the

universe is contingent and that everything is supremely ordered. In religious discourses concerned with the end of days and future salvation there is a profoundly optimistic and emancipatory belief in a renewal of the world brought about through its predetermined annihilation. During the apocalypse all evil is destroyed, human suffering overcome and existence is revealed as being meaningful. A millennial realm of peace and justice is created in the aftermath of the apocalypse. Evidently, as Daniel Wojcik notes, faith and fatalism are intimately woven into the traditional fabric of apocalyptic thought – a profound dystopian fatalism about a world believed to be mired in untruth and evil coexists with a sincere utopian faith in a predestined age of truth, harmony and human fulfilment.

In contemporary Western culture, not least in its popular cinematic works, the term 'apocalypse' is often used loosely to refer to any sort of global disaster, with little or no reference to divine revelations about the end of world history, or emancipatory expectations of a supernatural scenario involving the annihilation and renewal of the world. The word has been all but evacuated of its meaning, with only vague connotations of doom associated with its continued use. However, it is still possible to try and more strictly define apocalypticism and the apocalyptic in the contemporary situation as those beliefs and discourses that posit the cataclysmic annihilation of the world as inevitable and unalterable by human effort. Similar terms are used to describe both redemptive and unredemptive visions of the end, together with what Žižek has called the 'zero point of radical transmutation'[3]. The sense of fatefulness about the inevitability of global annihilation, whether it is believed to be either divinely predetermined or the inescapable consequence of the destructive behaviour of human beings, distinguishes apocalyptic thought from other types of catastrophic speculation that predict imminent cataclysms but assert that human beings can intervene to prevent them. Western secularization has not extinguished

apocalyptic thought, rather it has assisted in creating new forms of apocalyptic myth, ones that are more palatable to contemporary, popular culture, and much closer to a fatalistic form of nihilism.

One of the most persistent themes in contemporary apocalypticism, both religious and secular, is that the end of the world will occur as a result of nuclear annihilation, although environmental catastrophe due to global warming runs a close second. Within traditional religious apocalypticism the last days of the world are characterised as a period of signs and portents that reveal the imminence of doomsday and Christ's second coming, at which time all existing evil will be judged and destroyed. It is certainly the case that traditional apocalyptic predictions provide a means of making sense of otherwise incomprehensible, tragic, or distressing events by intuiting and identifying them as divine signs that are part of God's plan. Many apocalyptic beliefs present all of history as preordained and human agency as ineffectual in altering the outcome of events. Apocalypticism offers a tragic form of discourse composed of explicit religious theodicies: assertions of order and meaning that provide solutions to questions of why there is so much evil, suffering, and death in the world. It is a tragic and fatalistic mode of thought offering privileged explanations that disclose the otherwise obscure meanings behind world events and our experiences. All that occurs within the world is ultimately meaningful within God's larger design. With ultimate control in divine hands suffering is not cruel, contingent or absurd in an insensitive and meaningless universe but has a larger, symbolic meaning as part of a transcendent order.

Within both religious and secular apocalypticism, despite the fact that global annihilation is inevitable, specific actions to save oneself and one's family and friends from the horrific consequences of apocalypse and eternal damnation are prescribed. Fatalistic resignation about the irredeemable nature of this world

does not result in total passivity. Although the end of the world is fated, the destiny of one's own soul and the souls of others remains undetermined and is a matter of individual free will. One's individual spiritual fate may be altered through action, but at the same time the disastrous fate of the earth and the future of humanity as a whole are utterly preordained. Clearly this paradoxical way of thinking would appear to proscribe any attempts to prevent global catastrophe through social action, considering them to be either hopeless or downright sinful. One's responsibility remains steadfastly spiritual and individualist. The apocalyptic worldview liberates the individual from any uneasiness and responsibility that often characterises fatalistic belief – fatalism consists in the renunciation of one's own autonomous reason (hence also of one's own responsibility), and the hypothesis of a rational coherence of events in another transcendental register.

In the worldview that separates the transcendent divine realm and the material world, a global annihilation that is initiated from another realm makes sense – according to scripture it is inevitable. However, in our secular, contemporary situation, we have difficulty conceptualizing the imminent threat of global catastrophe from the will of a sovereign and transcendent God. Secularization has elevated humanity to this sovereign level where we now believe that we are in charge of our own destiny. This displacement of sovereignty has transformed our current ideas of the apocalypse. Perhaps because traditional religious discourse (particularly fundamentalism) has held onto the sacred view of the apocalypse or perhaps because much orthodox religious discourse in mainstream Anglicanism & Catholicism downplays the divine apocalyptic scenario, popular culture, particularly film, has taken up the charge and has begun creating elements of the contemporary secular apocalyptic ideology where the treatment of zero-point catastrophe is linked to specific effects of displaced sovereignty. More often

than not this is achieved through spectacular examples of contemporary ideological projection. The threat of annihilation is depicted as avoidable through some kind of reconfiguration of certain familiar elements associated with the nature of displaced sovereignty. More often than not, this occurs in accordance with certain dominant ideological axioms, e.g. returning to older certainties regarding nationalist identity, rediscovering the neglected value of the nuclear family, and through restoring abandoned religious faith. Contemporary apocalypticism is marked by the same anxiety regarding global annihilation that religious forms exhibit, yet its fatalism is much closer to destructive nihilism. According to Daniel Wojcik, fatalism, nihilism and powerlessness have become the trinity of secular apocalyptic thought.

The displacement of sovereignty onto man has lead secular apocalypticism to regard human beings and human activity as the cause of impending catastrophe. It regards humans as having the required structural (or logical) capacity to alter the fate of the world. Yet this secular challenge to religious fatalism merely gives birth to a new type of fatalism. Our awareness of human sovereignty vis-à-vis global annihilation co-exists with a profound pessimism, bordering on nihilism, regarding our implicit human nature at a species level and our collective *incapacity* to even imagine, let alone enact, the type of sovereign actions that would thwart global disaster. This fatalism regarding our implicit incapacity to either imagine or enact collective sovereignty results in a much worse form of fatalism; nihilism without the hope of any salvation. The symptoms of this nihilism seem to be superficially similar to the religious forms of fatalism, namely the passive acknowledgement of catastrophe. Except that here the real catastrophe is the becoming explicit of our incapacity to imagine or enact collective sovereignty. This is coupled with the *belief* that our individual sovereign actions can somehow save us from catastrophe. Confronted with the real threat of global

annihilation, the secular ideology of capitalism represented within many presentations of apocalypse in films such as Emmerich's *The Day After Tomorrow* and *2012*, Spielberg's *War of the Worlds* or Shyamalan's *Signs*, spews out ideological solutions entirely oriented around the individual and its own singular form of sovereignty. The myopic solutions to the apocalyptic threat of global annihilation are almost entirely connected to private individual action, behaviour and belief. All sense of genuine collective human action is either disregarded as hopeless or impossible or it is displaced back onto a familiar nationalistic/militaristic agenda. The destruction of the world is inevitable and is entirely determined by the alien agency of our own collective sovereignty. The only remaining practical solution lies with the individual who remains the essential feature of contemporary apocalyptic ideology.

Contemporary religious apocalypticism interprets and renders meaningful everything from personal tragedy (family illness, disability, accidents, relationship breakdown) to collective disasters (the threat of nuclear annihilation, environmental catastrophes and social/political problems) by situating all of them within a cosmic strategy of divine design. In popular culture, particularly film, the response to the threat of apocalypse is mediated through an individualist secular ideology (capitalism). A peculiar form of individual sovereignty is repeatedly emphasised. To better grasp this I am going to look at some contemporary cinematic examples, starting with M. Night Shyamalan's 2002 film *Signs*.

M. Night Shyamalan – *Signs*

Shyamalan's 2002 film *Signs* tells the story of the ominous appearance of crop circles on an isolated farm, owned by the Hess family, which turn out to be signs of an imminent global attack by aliens. The film foregrounds a clear apocalyptic scenario of the millenarian variety, dramatising an eschatological

desire to perceive and decode apocalyptic signs. Across the world crop circles are a harbinger of the end of days. Although the circles turn out to signify the beginning of an alien invasion, they do not in fact constitute the 'signs' with which the film is ultimately concerned. The signs at the heart of the film are those associated with tragic and mundane events in the private life of the Hess family. They serve both as a catalyst for addressing a crisis in faith and provide the key to leading the family to survival and renewal. *Signs* is an entirely emblematic, arguably paradigmatic, case study of the post-9/11 cinematic apocalypse. This is evident from the blatant conjunction of apocalyptic dread (in the shape of an external alien threat), the ideology of the family, and a renewal of religious faith. The relationship between family, crisis and faith is absolutely central to its narrative. It is clear that all is not well with the Hess family. A rupture in faith has left them reeling in the depressive and disenchanted aftermath of grief. The film suggests that this grief is not just confined to them but is global in scope.

Following the horrifying 'accidental' death of his wife, Colleen, which occurs six months prior to the events depicted in the film, the Episcopalian minister Graham Hess, in his grief and anger, renounces his profession and belief in God. This loss of faith is precipitated by his wife's accidental death, which occurs when she is fatally struck by a driver who has momentarily fallen asleep at the wheel. This event discloses to Hess the meaningless and contingent nature of the world. At times the film is ambivalent as to whether Hess renounces his belief in the *existence* of God, or whether he has renounced his belief in a *benevolent* God. Whichever it is, Hess is thoroughly traumatised by the arbitrary nature of his wife's death and he is utterly resigned to a universe where God is an absent spectator upon a contingent spectacle, with little more status than a sadistic voyeur. Hess has a binary attitude towards many aspects of life; either there is belief or there is not, either there is hope or there is

fear, and either there is the comfort of faith or there is loneliness and alienation. Hess's binarism suggests a profound anxiety concerning chance, coincidence or luck as being emblematic of an ontology grounded in arbitrary, random and meaningless events. As Nietzsche famously observed, 'What really arouses indignation against suffering is not suffering as such but the senselessness of suffering.'[4] What is problematic is not that his life is plagued by suffering, but that all of his suffering has the existential significance of chance or accident: this is what cannot be redeemed by happier accidents of fortune with which he might be comforted. It is the *awareness* of this mindless fate that threatens Hess's life with a 'will-negating mood': not an impulse to end his life in another act of contingent violence, but to condemn his life to one of ongoing fear and anxiety. This awareness manifests itself as Hess's listlessness and physio-logical depression. The film depicts his journey back to a restored faith where his ontological anxiety associated with the aleatory is replaced by a belief in an utterly preordained narrative authored by God. The restoration of his faith provides the necessary hope and comfort for him and his family at a point of global catastrophe.

Hess lives on a remote farm surrounded by large cornfields in Bucks County, Pennsylvania, with his neurotic daughter Bo and severely asthmatic son Morgan, and his brother Merrill, a failed minor league baseball player with ambitions to join the military, who has come to live with his brother's family in the aftermath of Colleen's death. The loss of Colleen and the subsequent atmos-phere of trauma and grief are all pervasive from the very beginning of the film. Bo's neurosis takes the form of sleep-lessness and an anxiety about stale water, and Morgan appears deeply ambivalent towards his father. Complex and mysterious crop circles appear in the fields around their house, and they soon learn from the television that such circles are appearing all around the world. Thousands of UFOs appear in the sky across

the Earth, and it is revealed that the crop circles are somehow connected to an impending alien invasion. The film suggests only two possible scenarios for such an invasion – either friendly or hostile, and it is quickly established, not least through the encounter that Hess has with an alien scout trapped in a cupboard, that the invasion will be hostile.[5] The family are shown preparing for the catastrophic invasion, barricading themselves within their home whilst the aliens besiege and terrorise them from the outside. During the overnight attack the Hess family appear hopelessly trapped in their basement whilst Hess's son Morgan, who has forgotten his medication, has several serious asthma attacks and nearly dies. And yet the following day the aliens have abruptly departed and the attack is over. The radio reports that humans have successfully managed to defend the earth from the alien attack. As the family return upstairs they are confronted by an alien in their living room that has been left behind. The alien captures and threatens to kill the unconscious Morgan. In the process of this terrifying crisis Hess rediscovers his religious faith by recalling his wife's dying words, the incongruity of which have plagued him since her death.

Shyamalan's film has three flashbacks which incrementally depict Hess and Colleen's final farewell at the scene of her tragic accident. The first flashback occurs immediately after Hess and Merrill's discussion regarding those who either believe in and are comforted by signs, and those who perceive them as contingent and, as a consequence, live in a comfortless world of fear. Shyamalan's editing of these two scenes – Colleen's death and Hess's conversation – forces the connection between Hess's own loss of faith to the death of his wife. The flashback shows Hess (dressed as a pastor) arriving at the scene of the accident, and ends with the Sheriff, Paski, telling him 'She's not in an ambulance, Father.' The flashback does not disclose at this point that Colleen is fatally injured, and it does not depict the actual final exchange between she and Hess. The second flashback

occurs when the Hess family are trapped by the aliens in the basement of their home, resigned to their inevitable death. This flashback reveals that Ray Reddy's truck has hit Colleen, pinning her against a tree. It has severed most of the lower half of her body. It is revealed that she will not live; Paski tells Hess that 'Her body is pinned in such a way that it's alive when it shouldn't be alive'. Paradoxically both lifelike and yet already dead, Colleen's body is suspended between life and death, on the very threshold of earthly material life and the immaterial spiritual realm. The establishment of Colleen's paradoxical state is one of the most important functions of this scene; it offers a particular 'spiritual' signification to her dying words which are revealed in the final flashback.

This third flashback does not occur until after the climax of the film, just after the family have come up from the basement, having survived the night, to confront the alien who has captured Morgan. As Merrill and Hess approach the alien it threatens Morgan with a poisonous gas exuded from its wrist. A tense standoff ensues. It is at this point that Hess recalls Colleen's dying words to him, as the flashback returns in its longest version.

Colleen: Tell Morgan to play games. It's okay to be silly.
Graham: I will.
Colleen: Tell Bo to listen to her brother. He'll always take care of her.
Hess: I will.
Colleen: Tell Graham...
Graham: I'm here.
Colleen: Tell him...to see. Tell him to see. And tell Merrill to swing away.

Hess has not previously disclosed Colleen's injunction for him 'to see', only having told his brother about her having said for

him to 'swing away'. The sudden recollection of her injunction to 'see' links his vision to revelation. Graham suddenly realises that his wife's final words were in fact prophetic. He 'sees' Merrill's old baseball bat mounted in pride of place on the living-room wall and, at moment the alien tries to kill Morgan, tells him to 'swing away'. Merrill immediately understands these words, retrieves his baseball bat and attacks the alien – 'swinging away'. Morgan's life is saved. As Merrill hits the alien he accidentally knocks over one of the numerous glasses of water left around the house by the neurotic Bo, which sprays over the alien, burning it like acid. Upon discovery of the alien's weakness, Merrill defeats it by smashing all of the glasses of water Bo has left around the room. With hindsight Hess not only believes his wife's dying words to be a prophetic sign from God, but that every single event he had seen as contingent was in fact determined by God, and that all were 'signs' from God leading him to the point where he was able to save his family's life from hostile attack by aliens, and ultimately his own existence from the threat of nihilism. This is signalled when Morgan, revived after the alien's death, says 'Dad, did someone save me?', and Hess responds by saying 'I think someone did'. Having all survived this apocalyptic crisis the Hess family are reunited through the restoration of belief, which is signalled by a long scene, framed by the family home, where the four of them digest the implications of the 'miracle' they have just experienced.

By finally remembering and seeing, Hess now comprehends God's signs, and is renewed in faith. His aleatory anxiety is replaced by an apocalyptic insight in which catastrophe is revealed as divinely authored prophesy. All world history (including all history to come) is revealed as following a proph-esied course, which the careful decoding of signs (which is, after all, part of Hess's assigned role as a pastor) can begin to antic-ipate. All of the discrete traumatic events that have happened to his own family, from Colleen's death, Morgan's asthma, Bo's

childhood neurosis concerning water, Merrill's failure on the baseball field, and the alien attack itself, become part of a divine master plan. Hess realises that his wife's final words were signs that would eventually lead to saving her family long after her actual death.

In the film's weird celebration of such fatalism, the fact that such events are preordained rather than associated with chance is presented as somehow comforting. It suggests that violence and terror are more horrific when they are meaningless than when they are part of some great divine plan. Apocalyptic faith offers Hess a way of dealing with the traumas that have beset his family by retrospectively comprehending that violence, terror and death have all been part of a divine master plan. All that has previously been inexplicable, random and meaningless is revealed, through the understanding of signs, to have had a hidden purpose. The adoption of this eschatological perspective allows Hess to arrive at an understanding of everything that has happened in his life, and in the life of the world, in apocalyptic terms.[6]

Two of Shyamalan's subsequent films *The Village* and *The Happening*, continue to explore themes opened up by *Signs*. The first of these, which depicts a late nineteenth-century community living in a state of siege in the woods, is clearly connected with a response to external attack, trauma and grief. With one of Shyamalan's trademark 'twists' it turns out that this community is not at all what it appears to be, and is in fact made up of a collective of twentieth-century traumatised victims of criminal violence (played by William Hurt, Sigourney Weaver and Brendan Gleeson) who have made a self-conscious decision to abandon and withdraw from twentieth century life, have children, and live a simpler holistic life hermetically secluded in the woods. Most have suffered meaningless acts of extreme criminal violence which has robbed them of loved ones. Their mindset is explicitly apocalyptic, having reached a point where

they consider twentieth century culture to be irremediably corrupt and doomed to disaster. However, part of their utopian plan involves the creation for their children of a permanent sense of threat from the outside (some monstrous other from the woods stalks the perimeter of their compound) in order to secure the ongoing social stability of the community. Shyamalan's film echoes, none too subtly, the pervasive cultural milieu post 9/11 where the Bush regime capitalised upon the attack to construct an apocalyptic and siege-like mentality amongst the American public in order to augment an intrusive homeland security agenda and aggressive foreign policy agenda via the war on terror.

The second of Shyamalan's subsequent films is more obviously apocalyptic, but is a much less successful retelling of *Signs* (and by virtue of that, *War of the Worlds*). *The Happening* is a film about spiritual malaise and existential despair which is brought about through a crisis in interpersonal relationships and external agency. This time the attacker seems to be nature (although it is left hopelessly vague) which is responsible for producing an epidemic of people committing suicide in a vast array of different ways. The mechanism by which this agency provokes mass self-destructive despair is never made clear. However, rather troublingly, Shyamalan does seem to suggest that what provokes this agency into action is not in fact man-made environmental damage (it is not a question of nature getting revenge on humans for damaging the earth), rather, it is shown to be somehow the response to a collective fracturing of natural relationships between human beings. Here Shyamalan is revealed as having a conservative agenda (which was of course present in *Signs*), whereby our collective failure to commit to orthodox loving relationships in modernity leads to nature taking a terrible revenge. It is as if by resisting what the orthodoxy regards as natural in terms of relationships, nature is going to exact a terrible price. The film ends up being a like a

weird fundamentalist version of Spielberg's *War of the Worlds*, except that the themes of cultural and familial renewal are not being tested by an alien threat, but policed by them in the shape of nature itself.

Stephen Spielberg – *War of the Worlds*

Like Shyamalan's *Signs*, the narrative of Spielberg's 2005 adaptation of HG Wells' famous apocalyptic story of alien invasion, foregrounds the troubled territory of the fractured American family. The familial divisions and conflicts here are those associated with divorce rather than death, although the effects are shown to be just as fatally necrotising.[7] The main protagonist, Ray Ferrier, finds redemption in rediscovering a sense of responsibility within his displaced paternal role. This rediscovery occurs as a result of a confrontation with the apocalyptic threat of an alien-led genocide, having his 'eyes opened' onto catastrophe, and having to defend his two children from almost-certain death.

The film contains extensive references to the 9/11 attack and external terrorism as the new marker of dread and horror in the twenty first century, with Spielberg acknowledging that his film is 'about Americans fleeing for their lives, being attacked for no reason, having no idea why they are being attacked and who is attacking them.' Like many other disaster movies made at or around the turn of the century, including *Armageddon* (1998), *Deep Impact* (1998), *The Day After Tomorrow* (2004), *2012* (2009) and *Knowing* (2009), Spielberg's film places the American family at the centre of a profound threat and links its survival to the national and global crisis. The alien invasion at the centre of this particular film's narrative becomes a thinly veiled allegory about the anxiety of proximity, alluding to the 'enemy within', echoing a deep cultural fear over the invisibility of sleeper cell Muslim terrorists. However, whether it is environmental, cosmic, alien, terrorist or mystic, the spectacle of global catastrophe depicted in

all of these Hollywood films, without exception, appears to be of concern to only an extremely small number of protagonists/survivors where the overriding theme is an ideology of the nuclear family.

The film's imagery includes numerous examples that specifically elicit the cultural iconography of the 9/11 attacks and the destruction of the World Trade Centre, including clouds of clothing that float to the ground after the alien's death ray vaporises fleeing human beings; airliners falling out of the air; missing posters that are pinned up all over New Jersey; and people asking each other 'Did you lose anyone?' 9/11 is also evoked throughout the film by general images of disaster and destruction – a train on fire races past stunned survivors as they wait at the railroad crossing; a river full of bodies floats past Ray's stunned daughter; and the wing of a downed airliner lies amidst the ruins of a suburban street.

In the face of complete annihilation Ray Ferrier has to deal with the ghosts of his past bad parenting, and it is only through the global crisis that he is impelled to work at repairing his damaged relationship with his hostile teenage son and his neurotic daughter. Ferrier's family are depicted by Spielberg as everyday dysfunctional Americans (Ferrier has a blue-collar job and lives a modest working-class life). Significantly, this everyday family is haunted by unacknowledged faults, failures and personal betrayals that divide parent and child. Much like the Hess family in Shyamalan's Signs, the Ferrier family are alienated and depressed, yet they appear to be in thrall to a much less tangible sense of loss and grief than the Hesses.

Rather than promising a miraculous rejuvenation, Spielberg's *War of the Worlds* offers survival to the everyday American family by demonstrating the necessary reconnection to a core essence of individual and familial responsibility. A more explicit exploration of this particular apocalyptic theme is played out in the 2009 film of Cormac McCarthy's *The Road*, which will be

discussed later.

As Ray Ferrier struggles to keep himself and his children alive he decides to set out on a pilgrimage to Boston to reunite his children with their mother. At the beginning of the film Ferrier is presented as a feckless, irresponsible and ineffective father, displaced from any proper sense of his parental identity through divorce. It is only when he and his children are placed in extreme peril at the hands of the invading aliens does he reconfigure a new form of parental identity that is not reliant upon there being a mythical rapprochement between he and his ex-wife. Ferrier, when faced with the annihilation of his family, is depicted as recovering a lost sense of responsibility, care and connection to his children, ultimately re-establishing a renewed sense of self-identity. At the end of the film there is no embrace between Ray and his former wife – only the redemption that he has discovered in being a good father, by bringing his children safely home to their mother (and Boston).

At the end of the film Spielberg points to the symbolic signif-icance of Ferrier's spiritual odyssey to Boston as a key site of the American Revolution. It is as if Ferrier's return to Boston signals a return to an originary site of resistance, independence and national dignity. In a key scene near the end of the film that the ideological core is revealed. Ferrier is shown examining a statue of a Minuteman covered in the alien's red creeper vines and notices that they are dying. Minutemen were a small hand-picked elite colonial militia formed around Boston during the American Revolutionary War (1775-1783). They were required to be highly mobile and able to assemble quickly, allowing the colonies to respond immediately to war threats, hence their name. Minutemen were among the first people to fight in the American Revolution. The explicit allusion to the emancipatory war of independence aligns the global crisis at the heart of the film with a peculiarly American story of national survival and renewal. Spielberg talked about his remake of *War of the Worlds*:

I feel more at home today, in today's world. And I think, in the shadow of 9/11, there is a little relevance with how we are all so unsettled in our feelings about our collective futures. And that's why I think, when I reconsidered *War of the Worlds*, post 9/11, it began to make more sense to me, that it could be a tremendous emotional story as [well as] very entertaining one, and have some kind of current relevance.[8]

Just as Colleen's dying injunction to Hess 'to see' reveals something crucial about the connection between trauma, catastrophe, belief and hope in that film, Spielberg suggests throughout *War of the Worlds* that looking and knowing are the only possible responses to trauma. By learning to look anew at the world in the face of external attack and national crisis, and by reconsidering one's relations to each other (albeit, restricted to relations within the family), Spielberg offers a space for a necessary, yet fatally limited, restoration of belief in the world. This restored belief is limited in terms of its explicit concern with atomistic domesticity and a nostalgia for a lost emancipatory spirit, rather than wider social and political relations. Although it is notably secular when compared with Shyamalan's *Signs*, both films operate on the limited register of the survival of the American family, and its necessary renewal through reconfigured post-catastrophic forms of seeing and believing.

One of the most recent apocalyptic films to emerge from Hollywood is the adaptation, directed by John Hillcoat, of Cormac McCarthy's extraordinarily successful novel *The Road*. Again, many of the themes identified in Shyamalan and Spielberg's treatment of the apocalypse are present in this film, which is self-consciously a more serious, emotional and thoughtful presentation of the post-apocalyptic situation.

John Hillcoat – *The Road*

John Hillcoat's 2009 film adaptation of *The Road* is ostensibly a

post-apocalyptic narrative where violent and grotesque images of social and material catastrophe are juxtaposed with glimpses of individual moral continuity. This moral continuity amidst the ruins is repeatedly cast within the notion of 'carrying the fire', a reference to Prometheus who in Greek myth gave humanity the gift of fire, thereby initiating an era of enlightenment and progress. In both the novel and the film there is an emphasis on vision and unveiling as central metaphors, which is something it shares with the apocalyptic narratives of *Signs* and *War of the Worlds*. However, it differs significantly in terms of its overall tone, pace and presentation. The two central characters are presented as those for whom the 'veil of history' has been lifted in accordance with the narrative's obsession with vision as a means of unveiling. Ultimately the film concentrates upon being a much more serious spiritual allegory celebrating the individual struggle to maintain moral clarity in the face of collective nihilistic savagery.

A father, played by Viggo Mortensen, and his young son struggle to survive after an unspecified cataclysm has destroyed civilization, killed almost all plant and animal life, and obscured the sun. Only remnants of mankind remain alive, reduced to scavenging or cannibalism. The man and boy are wanderers on the road, travelling southward in the hope that it will be warmer. Along the way, they ceaselessly search for shelter, food, and fuel, and avoid tribes of cannibals, all the while trying to maintain their own sense of humanity. The father and son's bitter struggle for survival in a North American landscape reduced to a grey post-apocalyptic wasteland is depicted as a moral, as well as material, struggle against barbaric nihilism. They self-consciously 'carry the fire' of a more civilised ethos associated with a lost society. Increasingly, the boy serves as the moral and spiritual touchstone of the story, in contrast with the diminishing figure of his dying father and the surrounding landscape which is 'barren, silent, godless'. In the novel, McCarthy describes how

they encounter 'secular winds ... in howling clouds of ash', and the road on which they travel is bereft of 'godspoke men'. They both traverse a 'sweeping waste, hydroptic and coldly secular.'[9] Despite the nakedly savage ontology of this world the boy is not to be dissuaded from his instinctively empathetic responses to others. Throughout the story his faith in his connection to other humans grows ever stronger, even as his journey with the man grows more desperate and the flame of his father's moral clarity begins to waver. The boy intuits the lost social environment, the lost civilization of the past based upon a collective ethos of care and compassion. It is he who carries 'the fire'.

The main arguments of The Road, in both the film and the novel, concern the failure of human collectivity in the aftermath of catastrophe, and the tension between the selfishness necessary to survive as an individual and the social altruism required to survive as a species. In a world bereft of any existing order, without the civilizing structures of generations of human history, a world in the last stages of its existence, *The Road* asks what the ethical behaviour of a human being should be fundamentally oriented towards – to itself, to others, or to higher humanistic or spiritual values? The original novel represents McCarthy's response to a perceived acceleration in the social erosion of ethical values in our contemporary situation. For McCarthy, our future – to say nothing of our present – invariably resembles an ethical wasteland when viewed from the vantage point of someone with an abundance of the established ethical culture of the past. He seems to suggest that, post-apocalypse, only collec- tivity at the most basic and savage level is possible: civilised collectives have to be rebuilt at the cellular or atomistic level. Evidently, the family unit, based upon unconditional bonds of love, care and responsibility, will be the last flame of true society to endure once all else has collapsed, the elemental point to which society will devolve and from which it must begin to rebuild itself – if there is any rebuilding to be done at all.

McCarthy lays out his vision for the possibility of a collective society in a post-apocalyptic scenario. Large-scale organised society has fallen under the weight of its own precariously complicated systems. The only organised collectives are pockets of barbaric and cannibalistic men that prey upon the weak. McCarthy sees this post-apocalyptic world in a moment of transition or change, but the transition to what exactly is left disturbingly indeterminate. Throughout the story he uses certain moments to show the hopelessness of revisiting the past and the importance of giving up these old marks of domesticity in order to make a new version of home, but one oriented upon the ancient familial bonds. For example the father and son visit a number of homes, including an old colonial house that has become transformed into a cannibalistic charnel house, and the ruins of the father's childhood home. In the middle of such moments the father and son form a society unto themselves – a deep and ancient familial bond.

The Road makes no promises as to the community's survival in their post-apocalyptic world. Community on both the micro and macro level is still threatened and it is clear that the intricate natural balance of the world, once destroyed, can 'not be made right again'. For McCarthy, the fate of mankind in a post-apocalyptic landscape is a profoundly ambiguous one, one fraught with peril and uncertainty – but one in which positive models of community have some chance of survival as long as there are men, women and children who will nurture, through belief, that small flame. His narrative certainly makes no promises as to where society might go, but that it is going somewhere away from death, away from inhumanity, is certain. Those things lie behind the new family that is formed at the end of *The Road*, but what lies ahead of them is a mystery. McCarthy leaves us some small room to hope that the future might be better than the present.

The Road, as a novel, serves as a warning, conveying to us that

the 'maps and mazes' of the world's becoming, once lost, cannot be recovered. Like the man's dreams and memories of the lost world, those maps and mazes are of a world that 'could not be put back. Not be made right again.' At one point he directly describes the revelation associated with this future apocalyptic world, when he writes that the man 'walked out into the gray light and ... saw for a brief moment the absolute truth of the world. The cold relentless circling of the intestate earth. Darkness implacable. The blind days of the sun in their running. The crushing black vacuum of the universe.'[10]

The father and son, resembling two abandoned characters from the pages of a Beckett play, scrape out a bare existence in a horrific post-apocalyptic milieu. They stay on the road less out of hope of discovering a better place, than out of a spiritual (which is to say optimistic beyond the bounds of reason) hope for a better social space. They carry the flame of hope that they will find other people who are not cannibals, others who carry the fire of a lost civilization. In a book McCarthy also published in 2006, *Sunset Limited*, this notion is referred to as the 'lingering scent of divinity' in the face of unbearable and inevitable nihilism. McCarthy suggests that, where there is no evidence of the divine, we will create 'a naked intent toward God', even out of the worst abomination and ash.[11]

The director John Hillcoat manages to capture on the screen a flavour of McCarthy's decimated North American landscape – a sprawling, horizonless vale of grey drifting ash and spindly rubble, 'the ponderous counterspectacle of things ceasing to be'. This is a landscape reduced to a rotting corpse of the natural world: 'Barren, silent, godless.' However, Hillcoat's film struggles to capture the remarkable ontological death of the world which McCarthy's novel so brilliantly and economically conveys through words:

The world shrinking down about a raw core of parsible

entities. The names of things slowly following those things into oblivion. Colours. The names of birds. Things to eat. Finally the names of things one believed to be true. The sacred idiom shorn of its referents.[12]

A formal failure of the cinematic presentation of *The Road* lies in its use of familiar filmic tropes, such as voice-over, flashback and musical soundtrack. All three of these tropes are commandeered to provide *The Road* with a sense of mournful, poignant and melancholic gravitas, signposts that we are watching an emotionally serious film rather than spectacular and thrilling entertainment. Whilst it is significant that it brackets off much of the thrilling spectacle associated with the apocalyptic filmic genre, it does little to differentiate itself from the conventional logic associated with much of these films. The film's soundtrack, provided by Nick Cave and Warren Ellis, appears as soundtracks often do in conventional Hollywood films, overbearing and manipulative, literally directing us to how we should be feeling at certain moments of the film, sometimes frightened, sometimes wistful, sometimes melancholic, and sometimes sad. This is accompanied by an impossible narrative voice-over by Mortensen, who is literally telling us the story as if placed in some out-of-place narrative position, from a place of transcendent safety other than the unrelenting fabric of despair in which the film is set. This narrative voice-over is doubly absurd since Mortensen's character actually dies at the end of the film and would no longer be in a position to narrate any of the events we have watched unfold.

Part of Mortensen's poignant, yet impossible, narrative voice-over involves the use of flashbacks to his earlier, pre-apocalyptic life. Here we are presented with contrived idyllic scenes of tenderness between he and his wife (played by Charlize Theron), as they tend horses on their beautiful property in the countryside. The flashbacks become increasingly dystopic as the

nameless catastrophe occurs and they end up barricaded inside their property struggling for survival in the aftermath of the birth of their son. These conventional cinematic tropes supplant imagination and thought in the presentation of the apocalyptic scenario, in a way that the novel manages to preserve. This loss is not, however, inevitable due to some intrinsic characteristic of film, but is rather the result of poor directorial and artistic decisions made by Hillcoat whereby he decides to rely upon conventional common-sense film logic (in fact, the same logic at play in Shyamalan and Spielberg) in order to present *The Road* as an affectively harrowing piece of serious cinema. There is a failure to defamiliarise and to create the requisite sense of detachment, disassociation and estrangement since this is a film that ultimately draws upon the mechanics of familiar common sense in creating its vision of the post-apocalyptic. This fact can be clarified by turning to a striking and original cinematic presentation of the post-apocalyptic scenario that attempts to think apocalypse differently. The film is Michael Haneke's often overlooked counter-sense masterpiece *Time of the Wolf*.

Michael Haneke – *Time of the Wolf*

My films are intended as an appeal for a cinema of insistent questions instead of false (because too quick) answers, for clarifying distance in place of violating closeness, for provocation and dialogue instead of consumption and consensus. Michael Haneke

Michael Haneke is an Austrian filmmaker and writer best known for his bleak, austere and disturbing style of filmmaking. His films often document enduring moral, political and spiritual problems and failures in modern Western society. His feature film debut was 1989's *The Seventh Continent*, which established the highly original style with which he has become synonymous. Several years later, the controversial *Benny's Video* and the

counter-sense masterpiece *71 Fragments of a Chronology of Chance* secured his reputation as one of the most fascinating and challenging contemporary directors. He went on to achieve both critical and commercial success with a number of subsequent films, including *Funny Games* (1997) and *The Piano Teacher* (2002) before directing one of his most underrated and least discussed films, the post-apocalyptic *Time of the Wolf* (2003).

Haneke's *Time of the Wolf* shares with *The Road* the notion that the apocalypse has already happened, the cause of which remains, to a certain extent, ambiguous. As in *The Road*, there is no spectacle of the end of days. The catastrophe of the apocalypse is no longer a spectacle at all, rather it is of the order of an injunction for personal and collective social change. There has been a lacuna which produces a total displacement from the old familiar tropes of being, and the ejection into a terrifying realm of the unknown.[13] However, in contrast with *The Road*, the sense of displacement and alienation presented by Haneke's film is actually something communicated through formal cinematic means, i.e. it is not just the film's subject matter, but is a void embedded within the film's compositional logic of counter-sense. Haneke suggests that the only route left for the apocalyptic parable in cinema is to get at the moral through a radically new form of sensory experience. This is an experience self-consciously differentiated from the conventional common-sense logic of representation at play within the usual cinematic genre of the post-apocalyptic. It is the experience of an unspeakable and unrepresentable *void*.

Haneke's ambition in pursuing this aberrant cinematic presentation, and it is one pursued in all of his films, is to reawaken us to the weight of things we see and hear, and the responsibility we bear in seeing and hearing them. All of his films have a distinct social agenda, one that is very much linked to questions of cinematic presentation and perception. He insists that his own cinematic approach is a reaction against the existing

conventions that he considers to be utterly pernicious. The traumatic impact of events already taking place around the world is misaligned with the tradition of fast-paced, inconsequential cinematic events and spectacles and common-sense perception and cognition. By self-consciously breaking with established conventions Haneke challenges the lack of distinction between the cinematic and the actual, destroying the cinema's capacity to function as a place of passive moral refuge by shielding us from our complicity in the events of the actual world. For Haneke, 'the tendency of film to banalize all events through a kind of levelling process would seem to preclude the possibility of specifying any event as a catastrophe.'[14]

Time of the Wolf has an unprecedented visual and narrative austerity. In this story of catastrophe there is no familiar narrative voice-over, no flashbacks, no musical soundtrack whatsoever. The film also usurps the usual tropes within which post-apocalyptic dramas are framed, such as the individual moral fable evident within *Signs, War of the Worlds* and *The Road*, in favour of a much more complex moral landscape. The sense of displacement which results from the catastrophe that has already occurred is one forced upon us not merely through the represented spectacle but by the aberrant and austere logic of that presentation. Throughout the film we are offered few of the narrative reassurances often evident within traditional cinema. We are told remarkably little about any of the protagonists' backgrounds, there is no back-story to the catastrophe that has occurred, no artificial voice-over, musical soundtrack or progression towards resolution. This is a counter-sense logic of folds, lacunae and irrational juxtaposition. The disruptive grammar at play here is profoundly uncomfortable. The narrative is forced to adhere to an elliptical structure which rotates about a void. The protagonists, whose fate we follow up to a certain point, are no more prepared for the events that unfold than we are as viewers of this film. They have no ready-made roles to

occupy in the face of disaster, as opposed to so much apocalyptic cinema. The effect of this counter-sense presentation of the post-apocalyptic is profoundly destabilising, challenging, disconcerting and ambiguous. This is evident from the very beginning of the film where we see a middle-class French family attempting to retreat from the unnamed catastrophe to their isolated country holiday house with their supplies. Haneke immediately disrupts this notion of atomistic retreat to private property by having their country home already occupied by another foreign family[15] who very quickly kill the father and steal the family's supplies, ejecting the mother and children back out into the world. With the death of the father and the destruction of the private realm as a zone of safety Haneke ruptures the family and creates an almost unbearable sense of homelessness. The mother and children (Anna, Benny and Bea) wander around the local area amongst a community of people they once vaguely knew as bourgeois weekenders. Now they are met by a lack of hospitality from those who have taken to barricading themselves inside their homes. It is clear that the conventional social obligations and responsibilities no longer hold, and they are forced to take to living in a barn.

As the film progresses, the mother's individual struggle for survival with her two children becomes lost in the contentious struggle to reformulate some kind of primitive social fabric, and the film roams and refocuses on the other survivors. Indeed, the film depicts a shift in the conventional concern with the individual protagonists into what initially appears to be a relatively stable collective (as individuals gather in the waiting room at a train station), but then shifts again as that collective is further subsumed by the arrival of an even larger group of refugees who don't even recognise the small group of refugees waiting at the station as a separate group at all. There is an incremental logic of dispersal at play in the film. Our attention is continually shifted from a small number of individual protago-

nists to a larger and more amorphous social group. The mother and children end up waiting at a train station with many other refugees for a train to arrive to take them back to the city. The station becomes a fluid interzone where the dispossessed, homeless and foreign collect and wait. Here, where the mother and children become absorbed into a new post-apocalyptic collective, the film shifts its priorities from the self to the many, and the penultimate scenario is a disjointed vision of collective love in the ruins. All of the characters are dealing with their own private struggles in public, none of which seem to have narrative priority. Human beings are shown as instinctively gathering together to regain some vestige of an ordered society which they have lost. They quickly establish a hierarchy and adhere to basic, functional patterns of labour, law enforcement, and food distribution to survive. Out of the grief at all they have lost – a passing train is a symbol of an entire vanished world – mythical stories of self-sacrifice, redemption and salvation flourish. Stories emerge regarding the mythical figures of the 'Just', thirty six messianic individuals who somehow guarantee the continued existence of humanity despite the apocalyptic disintegration that has overwhelmed it. In the penultimate scene of the film the young boy Benny attempts to sacrifice himself in the fire according to the mythical stories of the 'Just' that he has heard. In this scene, where Benny is rescued by one of the men who guard the station at night, Haneke seems to suggest that an ineffable belief in the future is as crucial to long-term human survival as food and shelter. As the man says to Benny, 'it's enough that you really wanted to do it.'

The film's depiction of the struggle between different ethnic groups at the train station-refugee camp also implies the possibility of a collective utopia – as if these parties were able to create a new, more democratic, and genuinely pluralist society grounded in a sense of mutuality in difference. The train station becomes an allegory of a world consumed by an entropic and

Beckettian sense of hoping and waiting in an eternal present; whether this present is allowed to move forward into some kind of futural dimension depends on its ability to redefine its approach to political, ethnic, religious and cultural difference. Haneke's fragile political vision is informed by an oblique political utopianism, where the only option in the negotiation of irresolvable social conflict is the hope that this conflict gets cast into a new and radically universal language. *Time of the Wolf* is a post-apocalyptic film that, in contrast to many examples of the genre, resists optimistic hints at civilizational renewal through a nostalgic return to the familiar. It refuses to end with a nostalgic vision of the future, whether positive or negative. Even *The Road* ends with the hint of future salvation through renewed family bonds. For Haneke it is important to realise that this future is in our hands, it is our choice and responsibility. We cannot fall back upon the palliative reassurances of the past, since it lies in ruins. The film offers us no false optimism or easy and reassuring predictions.

Haneke's apocalypse terrifies because it *ends* nothing – Haneke's apocalypse neither condemns nor delivers, it simply perpetuates. The cycle of existence continues. It tells us little or nothing about what we will become after the catastrophe of the apocalypse, but everything about what we actually already are. Haneke's survivors neither decisively pull together in an established order based on clear ethical principles, but nor do they fall apart. Their relations are merely fluctuations in an incessant state of desperation marked by human cruelty. This is not the construction of yet another post-apocalyptic myth, it is something far more disturbing. The fact that none of Haneke's survivors can be easily classed as truly despicable emphasises the extent to which the violence we perpetrate upon the world has crept into our normal everyday relations. Haneke's apocalypse does not sever our existing modes of relation, our ongoing cruelty, it maintains and promulgates them in previously

unforeseen ways.

Even in the realm of ultimate moral transgression (such as murder), Haneke's survivors are reduced to being passive witnesses rather than responsible agents, denying their volun- taristic agency even as they exercise it, fashioning their world even as they refute their authorship. Reflexively, as a work of apocalyptic cinema, *Time of the Wolf* is not about revelation at all, rather, it is about the recording of a decisive action – seeing, which is an action which habitually denies that it acts. For Haneke, in contemporary life the act of viewing has become increasingly passive, irresponsible and inert. Through the mass-media we are encouraged to become mere passive witnesses to events in the world. We have become impassive abstracted viewers. The alleged effectiveness of conventional apocalyptic cinema resides in its distantiation which is parasitic on this quotidian perceptual passivity; we watch 'our' destruction but always from a safe distance, the visual immediacy of catastrophe transformed into spectacular popcorn-accompanied audio-visual abstraction. This is what provides the weird shock in Haneke's final, subtle visual switch, mounting his camera on a train upon which vaguely glimpsed, immovable figures had earlier passed by Anna and her children, deaf to their entreaties. For Haneke the world will not end with decisive voluntaristic acts but with the inert passive look, a time of banal images which we ourselves have conjured, making us mere spectators to the destruction or salvation that awaits us. The mysterious final shot of the countryside shot from the moving train perfectly encapsulates the passive perspective on the entropic movement of the world around us. We merely look upon the world, inert, insensitive and indifferent.[16]

Arguably, there is a real space of hope opened up by the austere and counter-sense qualities of Haneke's cinema. The aim is to change our passive relationship to the actual world we 'see' around us, to effect an altered politics of vision and to change the

way we look at the world. The cinematic forms pursued by Haneke are those associated with radical de-familiarisation and cognitive disturbance. He violates our trust in conventional and traditional forms of storytelling in cinema, and occasionally in ways that appear nihilistic. In all of his films there is a challenge to mainstream representation and the deadening of thought regarding different possibilities for being and acting. This is precisely how his challenging and complex films begin to seriously approach the broader cultural problem of passivity and nihilism. In *Time of the Wolf* he seeks to liberate representations of the end of the world from being easily imagined and consumed spectacles. The end of the film is configured as a void in perception, an abyssal ellipsis in the visual fabric. Only film viewers subtracted from the comforts of a world framed in typical Hollywood genre expectations can begin to form *new* expectations of their culture. The self-conscious break from the narrative and cinematic styles of mainstream Hollywood cinema is not the nihilistic and reactionary act of breaking away from rational civilised culture. Rather, Haneke's acts of anti-conventionalism depart from the deadening effects of the stagnant traditions of contemporary bourgeois capitalist culture.

The formal counter-sense cinema of Haneke provides a very effective means to question the nihilistic common sense of the West. As a cinematic technique it is self-consciously evolved from the French film director Robert Bresson, who directed masterpieces such as *Joan of Arc* (1962), *A Man Escaped* (1956) and *Pickpocket* (1959). Haneke is clear about the positive influence of Bresson on his own cinema in a wonderful short piece he wrote in homage. For Haneke, Bresson discovered the formal means of reduction and omission in cinematic logic as 'the magic keys to activating the viewer'. Bresson discovered formal means for omitting the orthodox (and deceptive) invitation for passive emotional identification in favour of a more challenging and disruptive process of awakening. This involved working against

orthodox explanatory conventions in his films in favour of returning us as thinkers in an encounter with the concrete – 'as in our daily experience, chance and contradiction of fragmentary splinters of action demand their rights and our attention'. The common-sense notion of reality as a visible and comprehensible totality which can be encompassed and represented straightfor-wardly by film was utterly rejected by Bresson in favour of an aberrant filmic logic. This rejection represents both Bresson and Haneke's ongoing 'respect for people's capacity for perception and personal responsibility, that harbour in their gesture of refusal more utopia than all the bastions of repression and cheap consolation.' The austere political utopianism of both directors resides in their rejection of common-sense representation and their challenge to the passivity of the spectator. They make efforts to supplant orthodox film logic with an unfamiliar and productive new filmic sense, resulting in an active cinematic politics of vision. This politics resists the nihilism of the present and cultivates belief in new forms of collective being.[17] It also reinstates a utopian belief in the capacities of human perception to be transformed and as harbouring the creative imaginings of an entirely different state of affairs.

Counter-Sense Cinema and the Thought Yet to Come

A Sublime Shock to Thought

Most thought-provoking is that we are still not thinking, although the state of the world is becoming constantly more thought provoking...Most thought-provoking in our thought-provoking time is that we are still not thinking.[1]

Heidegger

Despite humanity having the capacity to think does not mean that it is thinking. Even at this most thought-provoking of times, what Žižek has called the 'zero point of radical transmutation'[2] that we are all living through, there is little guarantee of genuine thought. The prevalence of habitual thought, empty, repetitive and clichéd, is startling when confronted by the overwhelmingly nihilistic malaise of late capitalism. The modes of our habitual and everyday thought which we normally inhabit are always fossilized, dislocated, collapsed forms of thought. What is really needed is something which effectively emphasises and exhibits this prevalent lack of thought across our contemporary culture, in order to activate and put thought back into some kind of active and productive movement capable of resisting nihilism. Being directly confronted by our lack of thought can prove to be provocative, and to some extent can function to initiate the generation of thought. Indeed, it is possible that thought always depends upon the shock of our own everyday impotence to give birth to it, and as such it can only think one thing, the fact that we are not yet thinking, our powerlessness to actually genuinely think anything at all. I want to argue that counter-sense cinema can provide us with an experience where an essential lack of

power in thought is expressed and brought to visibility through the challenge of its formal configuration of images.

Following Haneke's example, I want to argue that counter-sense cinema can serve a vital role in the provocation of thought in this most thought-provoking of times, that it has a vital role in the politics of thought. As I discussed in the previous chapter, there are sequences of cinematic images in contemporary films by directors such as Haneke that present a powerful shock to our conventional modes of thought (not shock in the literal or representational sense, but in the structural or formal sense). When confronted by such cinematic sequences our mind is unable to assimilate that shock within its habitually coherent set of rational coordinates. Common-sense breaks down in this moment and experiences its own failure, its own limits or impotence. Such a specific failure in cinematic cognition is indicative of the fact that genuine thinking has not yet begun, that it is still to come.

The type of counter-sense cinema produced by Haneke has a dissociative power which is capable of introducing a figure of nothingness, a void in the stable fabric of everyday appearance. This is cinema which functions differently from the classic Hollywood form where the common-sense associative patterns of everyday thought in contemporary culture are merely reproduced. In fact this is something repeatedly explored throughout cinema's post-Second World War era, particularly in films by directors like Robert Bresson, Alain Resnais, Michaelangelo Antonioni, Jean-Luc Godard and Andrei Tarkovsky. For such directors, cinema does not just have the power to link images according to the demands of an established internal common-sense monologue, but also, more significantly, to un-link images from common sense and assemble them according to novel principles. Counter-sense cinema, as soon as it takes on a formal aberration of movement, carries out a suspension of the everyday world or affects the visible with a disturbance, which, far from making thought visible, is on the contrary directed to what does

not let itself be thought in thought, and, equally, to what does not let itself be seen in vision. Here thought is brought face-to-face with its own impossibility, and yet draws from it a higher power. What provokes thought is, on the one hand, the presence of something unthinkable and unrepresentable in thought (which could be both its *source* and *barrier*); but also the presence of another, much larger, thinker within the thinker. It is this larger and unsuspected other 'I', provoked by the void of the unthinkable, which interrupts every narcissistic monologue of the thinking smaller 'I', which wrenches the self out of its solipsism and its slavish adherence to the logic of the present. What the shock of this type of cinema forces us to confront and think is this 'outside' thinker that is deep 'inside' the small everyday thinker that we have so often been reduced to. The thinker that has been forgotten, overlooked and ignored.

As I have already discussed earlier in this book, classic Hollywood cinema often just reproduces the ordinary habits of thinking of our smaller 'I', to reinforce its established inferential associations, assumptions, prejudices and beliefs. This is not really thinking at all, more of a quotidian ventriloquist act. In much Hollywood cinema there appears to be a natural accord between the sequences of images produced and the perceptual and cognitive apparatus of the smaller 'I'. This allows the figural language of this type of cinema to become easily aligned with the inner monologue of the typical spectator. The aim of most contemporary Hollywood cinema is not to provoke thought through disturbance, but to produce easy enjoyment through thoughtless affect. Arguably the current enthusiastic pursuit of 3D technology across different genres within Hollywood is emblematic of such an aim. However, there remains a type of cinema with an ambition for provoking genuine acts of thinking which takes its inspiration from the original Heideggereian insight – i.e. it formally exhibits the current lack of thought and solicits the limitations and incapacities of the smaller 'I's

thought, in an effort to provoke genuine thinking.

In his two books on cinema Deleuze developed an original account of the power that certain forms of cinema have to produce this shock to thought, where the limitations of our current thought are dramatically figured and exhibited. In certain types of cinema there are wholly different principles of sequential linkage than that present in Hollywood cinema, which present radical changes to the way the relation between image and thought is conceived. Disturbances to thought can be produced by sequences of film being organised around funda-mentally different principles of sense, disrupting our habitual cerebral laws of resemblance and association.

It is as if cinema were telling us: with me, with the moving image, you can't escape the shock which arouses the thinker in you.[3]

For Deleuze the shock and violence to thought associated with this radical form of cinema amounts to a sublime conception of cinema. What constitutes the sublime in these types of film is the presence of formal lacunae. These appear as absolutely heteroge-neous, radically incommensurate to thought. When faced with these lacunae our everyday thought and imagination are pushed to their absolute limit. They struggle to make any sense of what they are being shown. Thought is forced to re-think the entire sense of what is being screened, as something entirely new which goes beyond our given modes of thought and imagination. Thought is provoked into an unfamiliar activity where it has to try and produce new sense. Sublimity consists in the degree to which these films force thought into activity precisely through their explicit difference or hostility to thought. In sublime counter-sense cinema, which finds its archetype in the European modernist or art film, this process of cognitive dissonance is reflected by characters who repeatedly find themselves in situa-

tions where they are unable to act and react in a direct, immediate or habitual way, leading to a breakdown in ordinary, everyday common sense. Haneke's *Time of the Wolf* is paradigmatic in this regard, presenting a deeply disturbing scenario of characters drifting within the void of a ruined post-apocalyptic world, unchained from normative sense and established social relations. In many other counter-sense films the sequence of images is severed from the familiar perceptual and cognitive links, which results in emancipation from common-sense for the spectator, and allows for the production of new sense.

How do the disconnected and abstract images of counter-sense cinema become reconnected as a flow of images? What is the nature of the form, or indeed, the unfolding of form, in this type of cinema? According to Deleuze it is not a matter of habitual or pure memory, but rather the disturbances of memory and the failures of habitual recognition and common sense. In counter-sense cinema the irrational lacuna between images in a sequence is absolutely fundamental to its formal operation. But what is this lacuna? A void. One that comes to exist between heterogeneous images – it is a separating or differentiating force that spaces images. It could be understood as that force which puts space between different images.

> What counts is the 'interstice' between images, between two images: a spacing that causes each image to be wrested from the void and fall back into it.[4]

This concept of the interstice is intended for a particular principle of creative composition in a new form of counter-sense cinema. The compositional challenge of this new form of cinema for the director becomes the question of how one is to begin with a given image and then move on to another image that will break patterns of habitual memory, shatter linear associations that pre-exist within common-sense. It is always easy (hence the notion of

habit evoked here), but essentially banal, to create natural and linear associations. The modern director has to confront this habitual logic of association and establish a compositional technique that will induce or evoke an interstice as a disruptive interruption between images. Deleuze writes:

> It is not a process of association, but of differentiation as mathematicians call it … a potential being given, one must choose another image, not any whatever, but in such a manner that a difference of potential is established between the two, which will be productive of a third or of something new.[5]

In counter-sense cinema one image succeeds another in a serially additive process. The interstice manifests itself in the radical discontinuities between visual images as well as in false continuities. The edit or cut between shots is not a rational cut that functions to conjoin images according to the habitually common-sense sequence of association. It is 'an irrational cut, which determines the non-commensurable relations between images.'[6] The irrational edit separates two cinematic images, but without being something that belongs to either. The cinematic images so conjoined through the irrational cut are not chaotically or randomly connected. Rather, these re-linkages are governed by some principle of higher purposiveness inherent within the interstice of the irrational cut – i.e. the interstice is a concrete principle of composition that embraces chance, accident, fold, error, or intuition as being somehow productive principles. A good example from Haneke would be his 1994 film *71 Fragments of a Chronology of Chance*, which, as the title suggests, is a fragmentary work consisting of juxtaposed sequences from unrelated stories which culminate in a final sequence showing a mass killing at an Austrian bank. The re-linkages between heterogeneous images throughout the film are manifestations of the interstice as a site or source of productive or creative difference, which culminates

in the sense of a profound cultural malaise, usually hidden, that has become manifest through the film. The interstice is pregnant with potentialities for new becomings. Counter-sense films such as these unfold neither mechanistically in accordance with a principle of habitual association, nor chaotically – they retain a compositionally meaningful principle that renders their unfolding musically purposeful.

The principles of re-linkage that govern composition in modern counter-sense cinema issue from a site of sense that appears to be beyond any external existing world. They do not seem to issue from either the visual fabric or from the viewer in any rational way, but from an outside that is always beyond the limits of our coherent common-sense universe. It is as if the force that provides the actual re-linkages between images, that provides the principle of flow that makes up the film's visual fabric, is something abstract, alien and outside. The connections or linkages in this type of cinema instigate a radical new mode of thought – one that is alien to our established modes of common-sense thinking. This explains their strange, disturbing and sublime quality. The cinematic sublime initiates an impossible and unfamiliar outside thought, a thought that is deeper than any common-sense inside. The power of this pure outside attests to a type of a-personal, de-realised other or alien thinker. It is as if the film were being thought by a radically impersonal thinker, alien and outside the film itself, and that it is this alien thinker who assembles the film through generating strange linkages that connect the interstices.

For Deleuze, thought 'as power that has never existed, is born from an outside more distant than any exterior world, and, as power that does not yet exist, confronts an inside, an unthinkable or unthought deeper than any interior world.'[7] This arousal of thought, which is initiated by the pure outside of counter-sense cinema, is a 'thought outside itself' and an 'unthought inside thought'. A pure outside becomes manifest within the cinematic

interstice, an irrational gap, interval or interruption between cinematic images. This pure outside is 'the constitutive "and" of things, the constitutive between-two of images' of counter-sense cinema. Each interstice is an expression or unfolding of the pure outside dispersing itself in a series of multiple and distinct interstices. The pure outside constitutes, through and in each interstice, radically non-rational links, to the extent that the world is itself now spaced through the force of its productive and generative intervals. The whole film becomes the 'power of the outside that passes into the interstice'.[8]

Clearly the principle of selection within counter-sense cinematic composition is that of productive differentiation. It is this type of additive structure, fabulation or formation which governs the way the contemporary American filmmaker David Lynch's films unfold. Most of Lynch's films can be understood as being composed according to a productive surrealist principle of the irrational interstice. This results in the gradual unfolding of a whole through the addition of heterogeneously intense images. Lynch explains this principle in his own, less philosophical, terms. For Lynch it is always just about the necessity of the story unfolding in its own unique way. Each story has, he claims, its way, its own being that unfolds according to its own immanent principles of becoming. For Lynch this is the reason why the stories in his films cannot unfold in a straightforwardly linear fashion, why they are always much closer to the aberrant logic of the dream. They cannot be governed by any pre-existing schema. They must unfold according to their own principle. The form of surrealistic abstraction, or dream logic, in Lynch's films is the entire fabric of the films themselves, it is their subject matter. That is, they are not composed of elements of the real and of elements of the dream. They do not have this binary structure. Rather, they are entirely of the dream, they are entirely abstract, but in being so function to return us to a more energised awareness of thought and our relation to the world. The world

not just as it already is, but as it might yet become. This renders Lynch (along with Haneke) a crucial figure in contemporary counter-sense cinema whose work, despite existing along the fringes of the Hollywood system, has had a profound impact upon thought and imagination.

David Lynch

Lynch's work has a marked reputation for being self-consciously weird, strange, obscure and difficult to comprehend. Indeed, his distinctive style has itself become a descriptive term ('Lynchean') applied to a whole range of recent films and television series that are seen as weird, from *Donnie Darko* (Richard Kelly, 2001), *The Machinist* (Brad Anderson, 2004) *Blood Tea & Red String* (Christiane Cegavske, 2006) to *The Kingdom* (Lars von Trier, 1994), *Carnivale* (Daniel Knauf, 2003) and *Lost* (J.J. Abrams, Damon Lindelof & Jeffrey Lieber). However, Lynch's own films are much harder to categorise than the 'Lynchean' tag would suggest. Through films such as *Blue Velvet* (1986) and the TV series *Twin Peaks* (1991-2) Lynch has been categorised as a surre-alistic chronicler of the underbelly of American suburban life, and with *Eraserhead* (1976), *Lost Highway* (1997), *Mulholland Drive* (2002) and *INLAND EMPIRE* (2008) as a post-modern horror stylist, purveyor of the extreme, of desire, violence and madness. Yet with his films *The Elephant Man* (1980) and *The Straight Story* (1999) he has been described as a filmmaker of the deepest humanism, bordering on the sentimental. Different critics have made a variety of allegations concerning Lynch's apparent misogyny, perversion, political quietism, naivety, sentimentality, wilful obscurity, confusion, and excessive violence. Other critics have praised his work for its imaginative power, its contribution to feminism, its honesty, its exploration of the American psyche, its passion and its sincerity. Such diverse critical reception alone gives some indication of just how difficult it is to present a consensus regarding Lynch's work.

Lynch himself consistently resists the attempt to provide determinate interpretations of his films in favour of advocating the surface affectivity associated with the films themselves and the vital solicitation of open-ended thought in the viewers. Lynch is keen to maintain a strict level of interpretative indeterminism with respect to his films and is content to allow his films to operate as catalysts to creative thought and interpretation by the viewer. The lack of determinate cultural meanings (e.g. psycho-analytical, political, or religious) means that much of Lynch's work succeeds in attaining a high level of conceptual indeter-minism. His films activate every element of the film-making process. Image, sound, movement, duration, music, and dialogue are used to capture and express a unique type of derangement of the senses, a derangement that Lynch claims is the attempt to figure the fragmented logic of dreams in cinematic images. In all of his work there is a unique sensitivity to the textures of sound and image, to the rhythms of speech and movement, to space, colour and the power of music. For Lynch the genuine power of cinema emerges when all of these elements fuse and produce what he refers to as a specific mood. Everything seen and heard during the film contributes to a very specific feeling in his work. The feelings that excite Lynch are those that approximate the affective sensations and emotional traces of dreams – e.g. that element of the nightmare that is impossible to communicate simply by describing a series of odd and disturbing events. Conventional film narrative, with its demands for logic and legibility, is therefore of little interest to Lynch as a filmmaker. In Lynch's universe worlds literally collide. There is a sense of unease in many of his films which is partly the product of delib-erate forms of counter-sense confusion, which is often perceived by the audience as the absence of the usual rules and conventions of classic Hollywood film that often afford comfort and orien-tation (e.g. the uncanny temporal dislocation in so many of Lynch's films between the 1950s-1980s). His films are not wilfully

obscure, weird, bizarre or grotesque as some critics have maintained, rather they should be seen as sincere attempts to provoke a sense of dreamlike dread or of the uncanny through counter-sense composition. These techniques, in Lynch's hands, attempt to transform the homely or familiar into the un-homely or the unfamiliar, to uncover hidden subterranean forces and provoke a disturbance or derangement of the senses. Even inanimate objects convey unspeakable malice. Insecurity and estrangement, lack of orientation and balance are sometimes so acutely presented in Lynch's films that the question becomes whether it is possible to ever feel at home in the everyday world again.

The indefinable mood of Lynch's work is strongly linked to a form of cognitive uncertainty and dream logic – what he calls being 'lost in darkness and confusion'. The effort to preserve the disjointed and vertiginous quality of the dream state is absolutely crucial for Lynch. The domestication of the dream must be resisted. Wittgenstein, writing of Freud's *The Interpretation of Dreams*, expressed his own discomfort with Freud's habit of interpreting dreams by seeking to provide an explanation of them in their entirety. Wittgenstein remained deeply suspicious of this type of theoretical reconstruction that seeks to view the dream as a whole object, or to provide narrative coherence to something so implicitly fragmented. In a dream, Wittgenstein writes,

it is as though we were presented with a bit of canvas on which were painted a hand and a part of the face and certain other shapes, arranged in a puzzling and incongruous manner. Suppose this is surrounded by considerable stretches of blank canvas, and that we now paint in forms: say an arm, a trunk, etc. leading up to and fitting onto the shapes in the original, and that the result is what we say: 'Ah, now I see why it is like that, and what those various bits are'.[9]

Wittgenstein's point here is not only that Freudian dream analysis (the painting in of forms) is suspect on account of its desire for familiar pictures; it is also that the Freudian technique proposes a solution where no problem has been offered. For Wittgenstein the effect of this process of interpretation is the gradual erosion of the specific nature of the dream canvas, which had originally represented only fragments and was by nature disjointed and incomplete. Elsewhere Wittgenstein remarks:

> What is intriguing about a dream is not its causal connection with events in my life [as Freudian dream analysis posits], but rather the impression it gives of being a fragment of a story ... the rest of which is still obscure.[10]

It is clear that for Wittgenstein there is a specific and inherent quality associated with the dream, namely fragmentation, and this solicits an impression of a unified story that doesn't actually exist. The actual elements that would make the story a unity are always hidden, obscure and mysterious, and any attempt to fill in those blanks (to paint in the forms) risks subsuming the precise quality of the dream. The coherent and unified interpretation only nullifies the specific energy of the dream. The dream must be maintained in its essentially fragmented state giving only the impression that it is a unified and coherent story. The problem identified by Wittgenstein remains one of how thought can serve to preserve the fragmentary quality of the dream rather than subsume it within the totalising sphere of reason.

This is no less Lynch's problem. He too has struggled to discover a suitable means to present the affective qualities of the dream state – its visions, sounds, and movements – without subsuming it to the confines of the everyday waking state. For Lynch this has involved embracing some of the formal qualities associated with counter-sense cinema, together with some of its aims. But for all of his efforts to reside within the dream state

Lynch is actually concerned with energising and renewing thought and its relationship to life. The energy of the dream, which he is so careful to preserve in his films, is sought as a means for altering and augmenting our ways of thought and being whilst awake. This is a therapeutic form of cinema. To make us dream is to make us think again. In making us dream, his films wrench us away from ourselves, from our habitual solipsism and cognitive comfort zones, and place us within a strange and unfamiliar arena controlled by an alien outside, beyond the everyday self. The power of this pure outside expressed within the Lynchean arena attests to the existence of a type of a-personal, de-realised other. It is as if Lynch's films were being thought by an impersonal thought, alien and outside the film. It is this alien thinker who assembles the film through generating the linkages that connect the interstices.

Perhaps the most extreme and successful example of this is Lynch's recent film, *INLAND EMPIRE*, which presents one of the most sustained experiments in destabilising alien thought in all of cinema. Throughout the entire film we are enclosed within a cinematic hall of mirrors where events repeatedly occur as the re-imaginings of a troubled psyche struggling to resolve the traumatic haunting by its own toxic psychology. Another example of this can be found in Lynch's 1996 film *Lost Highway*. In one striking sequence in the first part of this film the main protagonist, Fred Madison, recounts a dream to his wife Renee, but as he recounts this dream the logical and narrative fabric of the film becomes disrupted and irrational. We are left with an impossible moebius strip type structure that gives us the feeling that we do not know who is in fact doing the telling. Who exactly is the protagonist here? Is it Fred's dream that he is recalling? Is he in fact part of another dream? Are we actually seeing a dream within a dream? Are we seeing the dream of an absent dreamer? This disturbing sequence is a good example of the experience of being confronted by an impersonal thinker who is absent or

abstracted from the visual fabric of the film itself but who is providing the principle of linkage and composition from a pure outside. This is a central motif present in Lynch's entire cinema, which I will return to later. The impersonal other that initiates the compositional or structuring principle that governs the linkage of interstices, repeatedly manifests itself within Lynch's films. One of the effects of these phenomena occurs through the way Lynch's characters appear as if they were mere puppets that are being controlled by forces outside them. In the absence of rational forms of linkage that are so prevalent in narrative cinema, vision is radically disconnected from any stable point of view. This has an effect on the nature of the characters in the films. They become dissociated and abstract. It is as if, through the sequences of images becoming disrupted, the characters themselves have become disrupted. Such characters often do not have a full awareness of their circumstances, their own lives, their identities, or the identity of others. They become automatons, animated by principles from outside thought. This aspect of Lynch's films is consonant with much European modernist cinema, such as the films of Antonioni, where characters repeatedly find themselves trapped within situations in which they are unable to act or react in any direct way. For example, the main character of Alvin Straight in Lynch's 1999 film *The Straight Story* begins to resemble a Kierkegaardian Knight of Faith driven to perform the ridiculous act of travelling across America on a lawnmower to reconcile himself with his terminally ill brother because of a hyperbolic ethical principle imposed from the outside. His actions appear absurd to those around him.

Many of Lynch's other characters have this quality of spiritual automation, often manifesting in ways that Žižek describes through the idea of the 'ridiculous sublime'[11]. As Žižek notes, Lynch's characters have a sincere commitment to some mysterious, absurd or ridiculous principle that embodies their entire ways of being – I am thinking here of Fred's absurd principle in

Lost Highway: 'I prefer to remember things my own way, not necessarily the way they happened'; or Jeffrey's innocent and confused question in *Blue Velvet*: 'Why are there people like Frank in the world?'; or Frank's claim: 'I'll fuck anything that moves!'; or Sailor's statement of personal autonomy in *Wild at Heart*: 'This snakeskin jacket is a symbol of my individuality and my belief in personal freedom!'.

Lynch's characters often have an odd disassociated vocal intonation, mannered ways of behaviour, distinctive modes of appearance, or grotesque and exaggerated mode of comportment towards the world and others. Henry's robotic comportment, for example his hyperbolic hairstyle and his disassociated vocal intonation in Lynch's early film *Eraserhead*; or Frank's wildly exaggerated sexual and physical violence in *Blue Velvet* ('Feel my muscles!'); or Agent Cooper's idiosyncrasies in *Twin Peaks*, his ongoing monologue with 'Diane', his declarations of 'Damn fine coffee', and his eccentric and intuitive manner of criminal investigation; or Sailor's exaggerated sense of style in *Wild at Heart*.

Images and characters function as if they were the result of a non-human type of seeing – a floating eye, a primitive eye, multiple eyes dispersed across a smooth space. In this sense the sequence or flow of images within modern sublime or counter-sense cinema such as Lynch's, through which the characters move and interact, is one of disassociated, free and indirect vision and thinking. This has the effect of projecting these characters upon a dislocated trajectory of alien psychosis. Hence certain key refrains cited within the films themselves – 'Now it's dark' (*Blue Velvet*), 'Something bad is happening' (*Mulholland Drive*), 'It is happening again' (*Twin Peaks*). 'What happened?' (*Fire Walk With Me*) and 'Something is happening.' (*INLAND EMPIRE*). The characters are caught up in forces they can neither control or understand. The effect for us the viewer is as disturbing as it is exhilarating. Lynch's films deny us the type of

omnipresent requisite narrative information that more narrative-governed films provide. As we have already outlined, such narrative rules associated with Hollywood cinema serve the passive cinematic experience whereby thought is merely led along pre-determined paths of habitual association. All linkages are made according to the path of the habitual modes of thought. Lynch's films, by locating their principle of linkage in the power of a thinker located in a pure outside, preserving and expressing the affective quality of the dream, break with these narrative frameworks. We are no longer in the familiar cognitive territory of the small 'I', but have been wrenched into the vertiginous chamber of the larger and much less familiar 'I'. The logic of assemblage that we are confronted with is that of the impossible encounter in the dream. The movements of characters are expressions of the pure outside thought, and they appear to be driven by invisible forces – characters are doubled, replicated, they shift between worlds, inanimate objects are heavy with the material presence of menace, occurrences and events proceed by uncanny repetition and echo, parallel planes and universes emerge. All of these features of the Lynchean cinematic universe are the result of the linking power of the pure outside, the absent dreamer, the invisible hand of the non-human dreamer.

I propose to adopt the following four conceptual principles for approaching Lynch's counter-sense films:

1 His cinema is to be understood through the disruptive counter-sense sublime.

2 The entire fabric of each of Lynch's films is to be understood as being abstracted from representations of a real world. It is not the case that discrete elements within each film express the dream within an overall representation of reality. The entire visual and sonorous fabric of the films is the dream, and this is to be understood as Lynch's cinematic attempt to return us to a more energised

sensation of life through the artifice of the dream.

3 The compositional principle at work in Lynch's films is to be understood through the productive and differential interstice. This interstice is the principle that governs the way in which the films unfold through the addition of differential intensities (i.e. the (un)linkage of heterogeneous cinematic images through a principle of differential addition).

4 The visual and sonorous fabric of Lynch's films are best understood as being formed by a power of linkage that emerges from a force of the pure outside within the interstice. Their images, characters, and stories all become expressions or manifestations of this 'outside thought' and take the form of 'spiritual automatons'. At play within Lynch's cinematic work is a species of the surrealistic principle of automation, i.e. as in automatic writing or painting. However, one should resist the tendency for reducing Lynch's cinema as a classic form of surrealism. The automatism derived from surrealism is introduced as one of Lynch's ways of preserving the unique fabric of the dream logic. Automatism is maintained through the linking power of the pure outside that rests implicitly within Lynch's films – for example, as the figure of the absent dreamer.

These four principles enable an approach to the specificity of the dream logic as it becomes configured within Lynch's cinematic work, preserving the specificity of the dream's fragmentation in a way that Wittgenstein claimed Freud's dream analysis does not. The energetics solicited by that fragmentation are preserved without having to be subsumed by imposing a unified story, or filling in (or 'painting in') the blanks. Within Lynch's approach to cinema the specificity of fragmentation, of the assemblage of heterogeneous cinematic images, is celebrated as having a type

of productivity all of its own. It is the productivity of new thought in counter-sense cinema that renders Lynch one of the most important and vital film directors currently working.

Lost Highway

Lynch's 1997 film *Lost Highway* tells the story of the character Fred Madison. Fred is clearly a deranged and haunted man, a man condemned to a poisonous form of solipsism, to a form of psychological isolation from which he is unable to escape. In that sense Fred is not all that different from many of us. He is a character thrashing about upon the psychological equivalent of a *moebius strip*[12], pushed up tight against himself. The events of *Lost Highway* chart his doomed efforts to escape from this solipsism. The entire film emerges from the vortex of Fred's own poisoned mind which implodes violently and irreversibly. As a complex process of the projection of multiple fantasies and the subsequent decomposition of each fantasy, the film should be recognised as being constructed from a small number of complex and interwoven echoes of a series of specific events. Indeed it is as if a singular event were being repeatedly reinterpreted, as in an ongoing repeated dream. Whatever the reality of this event may have actually been, it has always already happened. We are never presented with it directly as viewers, but only through the composition and decomposition of Fred's fantasy interpretation. Fantasy and reality neither begin nor end, there is simply a *moebius strip* type continuum of Fred's interwoven fantasies presented as a series of spasmodic doublings and projections. Žižek, in his own work on *Lost Highway*, identifies a coherent logic that illuminates how fantasy is often structured and triggered (indeed as are many if not all of the fantasy narratives in Lynch's films):

'The logic here is precisely that of Lacan's reading of Freud's

dream, 'Father, can't you see I'm burning?' in which the dreamer is awakened when the Real of the horror encountered in the dream (the dead son's reproach) is more horrible than the awakened reality itself, so that the dreamer escapes into reality in order to escape the Real encountered in the dream.'[13]

The key to *Lost Highway* is a logic of an encounter with the Real in the thought of the dreamer, or this intercession in the composition of the dream narrative. Another example emerges in a dream sequence from *The Elephant Man*, where John Merrick, the 'Elephant Man', is confronted by figures that force him to gaze at his own disfigured face in a mirror. This spasmodic interruption of the Real, figured as the sublime moment, the 'hole in the dream world', provokes a hysterical response and drives the psychotic proliferation of fantasies that make up the narrative fabric of *Lost Highway*. The shock to thought from the Real that constantly disrupts and decomposes the fantasy narrative, yet also provokes a further composition of fantasy, is glimpsed by Fred at certain appalling moments in the film – the shock of being observed asleep, the shock of seeing Renee dismembered, the shock of the 'man from another place' being spatially and temporally dislocated, and the shock associated with acts of violence. These moments are the dark poisonous drains within dreams that threaten to drag the dreamer through them and confront them with the impossible – the reality outside of the dream. The narrative of the film is the complex continuum of the composition and decomposition of fantasy, interlinked through spasmodic moments of crisis. The poisonous drains of the Real provoke dread, fear and horror – which must be avoided. The gaze must be averted. One must leap away from the void of the Real. This fantasy continuum is suspended between the two moments that seem to mark the beginning and end of the film with an identical event – Fred as listener hearing the words 'Dick

Laurant is dead!' and Fred as speaker uttering the words 'Dick Laurent is dead!'. Within these almost identical moments there is a suspension of linear temporality that should discourage us from making straightforward narrative readings of any elements within the film. The fantasy continuum could, like complex dreams often do, occur in a moment.

The narrative continuum of the film is a repetitive interpretation of a series of events outside the dream that lead inevitably to a catastrophic encounter with the Real within the dream. What the Real outside the dream, the Real that provokes the catastrophic and psychotic proliferation of interpretative fantasies, actually is always remains open. Two moments between hearer and speaker which the narrative events of the film are suspended presents a moebius strip. The entire film revolves around an impossibility; Fred encountering himself – the event of his listening and his speaking bookend a proliferation of psychotic projected fantasy that suspend Fred in a solipsistic world of darkness and confusion. It revolves around the provocation of the impower of thought itself.

In presenting this fantasy continuum the film resonates with a coherence that can be unlocked through becoming open to the full sensuous presentation of the film. *Lost Highway* is precisely important in that it is wholly cinematic. It is a work that approaches cinema as a means for externalising and visualising the complexities and impossibilities of thought. Lynch's cinema of the sublime forces the viewer to observe the complexities and impossibilities of thought from an altered perspective. When we view *Lost Highway*, and other Lynch films, we experience the dislocated fantasy continuum of Fred's thought, we are forced to become dislocated from our own patterns of thought and are thrust upon the dislocated lost highway of Fred's psychosis. The effect is as disturbing as it is exhilarating. *Lost Highway* breaks the rules that apply in most conventional cinema, the biggest rule being that the viewer is never fundamentally challenged at the

level of the common-sense logic of thought. *Lost Highway* denies the viewer the type of requisite narrative information that more conventional films provide regarding the inner motivations of characters, who they are and where they're going, and whether they ever reach fulfilment. As I outlined earlier, such narrative rules belong to classic Hollywood common-sense cinema and serve the passive cinematic experience in which thought is led along pre-determined patterns of linear narrative, where all the connections have always already made, where there is literally no work left to do and there is nothing more than the superficial and surface shock of the spectacle. Even films which either directly concern vertiginous dream states, such as Nolan's recent 2010 film *Inception*, or warped alternative realities, such as Richard Kelly's 2001 *Donnie Darko* or George Nolfi's 2011 *The Adjustment Bureau*, ultimately disappoint in their quotidian adherence to the standard rules of narrative form. *Lost Highway* breaks these rules and actively engages the viewer. It provokes a genuine and disturbing shock to the patterns of thought.

Mulholland Drive

Lynch's 2001 film *Mulholland Drive*, originally conceived as a television series, is structured like a fragmented dream. It presents us with a hyperbolic exploration of the mysteries and paradoxes of identity. Like his earlier film *Lost Highway*, it too has a moebius strip structure that is exhilarating to watch and is a film that rewards repeated viewings. At the most fundamental level the film revolves around the mystery of the identity of the central protagonist, or the absence of a protagonist. At first the film presents us with the question of whether certain elements of the film are dream or fantasy, and the question of whose dreams or fantasies they are – Betty's, Rita's, Camilla's, Diane's, or Aunt Ruth's. There is a persistent mystery to this question of the identity of the protagonist. One might well argue that *Mulholland Drive* can be approached and read in a conventionally psycho-

logical way, but this would immediately perpetrate the same error that Wittgenstein talks about in respect to Freud's psycho-analytic dream analysis – the imposition of a unified linear narrative upon the fragmentary dream logic, effacing something about the specificity, energy and productivity of that fragmentation. Such an approach may seem a convincing account of what we are seeing unfold through certain fragments of the film. However, it is an approach that relies upon a type of retro-spective reconstruction that relies heavily upon filling in the blanks in an overly determinate way, completely subsuming the essentially fragmentary logic of the work. Such an approach to interpretation risks destroying the energy and vitality of the film itself as the presentation of a dream logic.

For the time being let us stay with this type of reading. According to this reading then, the narrative of *Mulholland Drive* consists of two distinct parts. It begins with a chance encounter between an amnesiac character who has escaped assassination through an accident, and Betty, an aspiring actress in Los Angeles. They both set out to discover the stranger's lost identity, with Betty assuming the role of the loyal and selfless friend. Interspersed with this unfolding story are various fragments concerning a film production, a dream, an assassination, and a search for a missing girl. Betty and the stranger (who has assumed the name Rita from a Rita Hayworth movie poster – *Gilda* (1946), a noir Hollywood thriller with the tag line 'There never was a girl like Gilda' – break into the apartment of a person whose name Rita has remembered (Diane Selwyn). They discover Diane's dead body. This gruesome discovery provokes Rita into having to disguise her identity, but this disguise (a blonde wig) strangely makes her look much more like Betty. Betty and Rita briefly become lovers (Rita expresses her absolute gratitude to Betty for all she has done for her, and Betty declares 'I'm in love with you', and that love appears to be reciprocated) before things then go very awry. Rita is disturbed by a dream in which she

intones 'no aye banda' and 'silencio', Rita takes Betty to the mysterious *club silencio*. Things get very strange at *club silencio*, where the disruption between appearance and reality is dramatised on a stage, in a way that has a series of effects upon both Betty and Rita and brings into being the mysterious Blue Box for which the key had earlier emerged from Rita's handbag.

There are things within this part of the story that suggest that Betty's true identity is not at all what it seems. For example, when Betty and Rita telephone Diane Selwyn (note that telephones in Lynch movies often signify the communicating links within a closed circuit of thought, hence the early sequence detailing a strange series of calls initiated by the mysterious 'producer' Mr Roke, and there are other examples of this in *Mulholland Drive* and also *Lost Highway, Blue Velvet, Twin Peaks: Fire Walk With Me*) Betty mutters 'it's strange to be calling yourself'. It appears at this moment as if she is speaking about Rita – but Betty is the one who is making the call. When the answer machine replies Rita's response is – 'That's not my voice, but I know her.' Much later in the film (during what might be regarded as its distinct second part or element) we hear the answer phone message in Diane's apartment (Diane formerly Betty) who would seem to make Betty's words actually ones about herself – 'it's strange to be calling yourself'. Betty and Diane seem to represent two poles within the circuit of a single identity that the film is going to provide all the necessary clues for us to discern. This is a temptation, but it is a temptation that would rob the film of its sublimity. According to this reading the unfolding chronology of the first part of the film represents an interpretation, in the form of an hallucinatory fantasy, by Diane of a real set of events (i.e. her corruption, desertion and murderous obsession with Camilla formerly Rita). The search for Rita's identity in the first part of the film locates Betty in the dominant but sympathetic role of investigator. However, this position has become completely dissolved by the time we have

reached the so-called second part of the film. There is a shift in the real question of identity in the film away from Rita/Camilla to the mystery of Betty/Diane. So are we seeing a hallucinatory narrative in the first part of the film as an expression of Diane's catastrophic grief and guilt? The hallucinatory re-imagining of her corrupted relationship to Camilla as figured through the Betty & Rita story, is led to the point of its own radical dissolution staged dramatically at *club silencio*. This occurs after her fantasised self-other in the form of Rita and her fantasy self, Betty, become lovers. This form of desire within the closed circuit of the fantasy universe becomes disrupted by this illusory desire, and having unleashed this disruption the unsustainable nature of the hallucinatory fantasy is realised at *club silencio* – 'it's all an illusion!'

According to this particular reading, even though the mystery of Rita/Camilla's identity seems to be driving the film forward, it is ultimately not Camilla's story that is being unfolded. It is Betty/Diane's. It is thus a film about Diane's subconscious, her descent from love, idealism and naïve ambition to obsessive and murderous psychosis. That descent can be read as being figured through the fragmentary and disintegrative logic of the film (i.e. its dream logic). The film itself becomes a literal sign of Diane's psychological torment, murderous intent and psychic collapse. Such a reading of the film explains the fact that Diane seems utterly condemned from the very beginning, despite all her attempts to hallucinate a reconstruction of that murderous obsessive descent, which would absolve her from responsibility. She is then, at the very opening of the film, delivered up into the pure light of grace by the two parental figures (they are later seen bringing her to The Angels, i.e. to 'Los Angeles'). We see however that these parental figures are actually sinister forces (they are what inhabit the mysterious Blue Box, and they are what the mysterious Blue Key opens). So from the very beginning the fantasised figure of Betty is accompanied by these two demonic

presences within her fantasised hallucination, two demonic spectres of her own making, whose presence contaminates and disrupts the consistent fabric of that fantasy. At the very end of the film these demonic parents return to Diane and deliver her into death. The first part of the film functions as a type of unsustainable repression through fantasy and hallucination (what Lynch has referred to as the condition of 'psychogenic fugue', although he will always ultimately resist such literal psychological interpretations), but it is always a fantasy that is haunted by the spectre of that which was to be repressed, symbolised by the demonic parental figures. At the end of the film there is a kind of literal return of the repressed element – a confrontation with the repressed Real. The dissolution between the boundaries of fantasy and reality that the film visually figures, together with Diane's increasing inability to make any distinction between these two realms, leads her to a point of absolute destruction – her fantasies are always contaminated and poisoned by an unthinkable Real, and her particular Real has become utterly unbearable and is ceaselessly infected by a hysterical literalising force of fantasy. Diane's destruction at the end of the film appears to end this interweaving of the Real and hallucinated fantasy.

In response to this form of reading is another, which determines more of what the film is not about. Self-evidently, the film is not a straightforward piece of common-sense narrative cinema, it is a radically irrational piece of counter-sense cinema that proceeds by the slow accumulation of various intense images and heterogeneous scenarios; the seemingly discontinuous cuts from Betty/Rita, the characters at Winkies, and Adam the director, the paradoxical confrontations with death, the corpse, the man (actually played by a woman) behind Winkies. It also should not be conceived as a film that just presents certain identifiable aspects of a dream which are then woven together with aspects of an apparently 'real' reality,

(despite the fact, as I've just demonstrated, that it can be read in precisely this way). I want to argue that the film just is the dream in its entirety. The film's fractured, fragmented and dual structure are all an essential part of how it attempts to figure the dream logic throughout its entire fabric. The characters we are presented with are fabrications in this deeper sense, they are the fabrications of an 'outside thought' (they are dream spectres, indeed, they are 'spectral automatons'). Ultimately this 'outside thought' is figured as an absent dreamer engaged in a desperate and irrational search for cohesion and identity. It is this final element, when we are presented with a radical 'outside thought' that unfolds through the irrational dream logic of the fabric of the film, which renders it a cinematically sublime work.

Mulholland Drive gives us a hypnotic, claustrophobic and enigmatic exploration of the mysteries associated with the production of identity. There is a consistent attempt within the film to bring together disparate entities within a unifying and stable identity. It's as the Cowboy says to Adam: 'There's sometimes a buggy – how many drivers does this buggy have?' The answer: 'One'. The film is driven by an attempt to re-align disintegrating identities of the characters with the 'one driver' – but a fundamental mystery remains – 'who is the driver?' There are various figurations of drivers in the film, from the Cowboy, the film-studio boss Mr Roke, the film-producers Jason and Mr Derby, the shady mob-financiers the Castigliani Brothers, and the film-director Adam Kesher. There is a complex circuit of controllers/directors who are at odds with one another, and with the actresses, over 'who is the girl', and indeed all would appear to be controlled by a further force, even more outside. Throughout the film there is a drive to establish that 'This is the Girl' from the fact that the 'Girl is still Missing'. One of the unnamed characters in Winkies describes how he has come to realise through having had a certain dream twice what it is, what is causing the sense of unease and discomfort. He says: 'There's a

man, in the back of the place, and he's the one that's doing it. I can see his face through the wall. I hope that I never see that face outside of a dream'. When he is led outside to confront it that dream logic is affirmed, there really is a man behind Winkies, and he is struck dead by the shock. Then there are the controlled, Diane/Betty Rita/Camilla, to whom the mysterious old lady says 'Someone is in trouble, something bad is happening!' Within this circuit of control and being controlled there is a desperate search for unity and stability.

At the heart of the film there lies an extraordinary analogy between the process of production of identity and the process of cinematic production.[14] This is further explored in Lynch's 2008 film *INLAND EMPIRE*. At play in the film are representations of certain elements concerned with the very production of cinema itself – in *Mulholland Drive* Hollywood as the 'dream factory' becomes literally figured in the film as a dream factory. But it is dream factory gone badly awry – as it has already gone awry in Billy Wilder's 1950 satirical masterpiece *Sunset Boulevard*. Lynch claims that *Sunset Boulevard* is one of the greatest films ever made and that it has had a tangible influence over a number of his films. Indeed, he insisted on screening it to all of the people involved in the production of *Eraserhead*. Many of *Mulholland Drive*'s elements take the form of complex re-imaginings of elements of Wilder's film – not least the bizarre, sideways and often satirical swipes at the dream factory that is Hollywood. Also of note is the fact that both films are marked by the same narrative paradox – *Sunset Boulevard* is narrated by a character who is already dead, and is telling the story of the events that have led up to his death, in the same way *Mulholland Drive* appears to be.

Various characters in *Mulholland Drive* express modes of the cinematic production process, the actors and actresses, directors, producers, financiers and studio bosses involved in making a film entitled 'The Sylvia North Story'. The film that is in the

troubled stage of pre-production, still at the level of pre-production casting, is explicitly figured as a film that will tell or unfold the story of a person who we hear named as Sylvia North. What we are presented with is the troubled nature of the production of this singular filmic story. There is a circuit of thought presented by this cinematic schema in *Mulholland Drive* aimed at generating a stable identity of thought. This circuit is an ongoing conflict between actresses, directors, producers, casting agents, studio bosses, but there are also dark and mysterious figures who are bound up with this circuit in a negative way, i.e. assassins, the Cowboy, the characters of *club silencio*, corpses, as literal figures of death. The entire fabric of the film can be read as this attempt at a closed circuit of thought between the controllers and the controlled, but it is a circuit that has gone awry, one where dark and Dionysian forces have been unleashed. These forces are death. There is a significant scene following the meeting of the two men at Winkies – indeed it emerges after the interstice of the character being confronted with the 'man behind Winkies'. As he collapses, apparently dead, there is a series of phone calls beginning with Mr Roke calling a man of whom we only see the back of his head, and telling him that the 'Girl is still Missing.' That man calls another on the phone, who answers by saying 'Talk to me', the first man replies with 'The same', (i.e. 'Talk to me'). To this order we see this man call another phone that is not answered, a phone that we see later is Diane's. This call seems to produce Betty, who appears at Los Angeles airport flanked by the parent figures. There is a parallel summoning in this scene to the one we see right at the very beginning of the film.

The story unfolded in the film revolves around the repetitive motif of an interweaved, moebius strip-like conflict between (at least) two parallel stories, i.e. the stories of Betty and Rita and Diane and Camilla. At the heart of this unfolding lies the mystery of the actual identity of the central protagonists. This will always

come back to a question of the 'absent protagonist', as is the case for all of Lynch's films. This alternative reading, in which the film just is the dream in its entirety, is one that can be unfolded further by looking specifically at the clues that Lynch gives to the film.

When the film was originally released Lynch published a number of clues to the film. Crucially, Lynch did not say what these ten clues are actually for. What is the answer for which these ten clues have been provided? There is a widespread perception that they are clues which allow one to unlock the mystery at the heart of the film. They are seen as keys which restore the rational notion of association that will make the film 'whole again' and indeed make it 'work'. This is a particularly unhelpful approach. Indeed, there is a significant presence of keys in the film itself (one of Lynch's clues), which serve to dissipate identity when used or activated (either through death or disappearance). When the figure of the assassin is asked by Diane what the blue key opens he laughs. Another idea regarding these clues is that they will allow us to reconstruct the coherent identity of the central protagonist in the film in a concrete way. To attempt to understand Lynch's clues in either of these ways is to explode the film's dream logic – it is to remain within the co-ordinates of a logic of identity that the entire film serves to disrupt. We should understand these clues as abstract signs that manifest as productive interstices within the fabric of the film. The ten clues that Lynch provides highlight ten partic-ularly productive interstices within the film, ten notable fragments within the dream logic, that work on the level of uncanny juxtapositions rather than rational associations.

What are these clues the clues to? Perhaps they are clues to assist us in breaking with a reading of the film that would attempt to over-determine it through a linear and representative approach, to break from the false dichotomy of reality and fantasy, or definite differentiations between states of dreaming

and awakening, or between the hallucinatory phenomenal and the Real. The ten clues allow us to begin to discern Lynch's radically sublime intentions for the film – namely that it is a serial assemblage of intensities, affects and forces rather than narrative events – it consists of an assemblage of figured forces rather than figured characters.

In order to illustrate this type of understanding of *Mulholland Drive* we can begin by analysing the first of Lynch's clues. Lynch claims that there are two clues prior to the opening credits (this constitutes one of Lynch's clues). Already, there is something strange in Lynch's formulation of his clues – it is a clue indicating the presence of further clues or a clue to further provocations if you like. So what exactly are these two pre-credit clues that Lynch alludes to?

1 The 'Jitterbug' sequence
2 The 'absent dreamer' sequence

These two sequences, following Lynch's lead, are obviously significant. As portals, they exist as abstract signs. They are portals through which we must enter before traversing Lynch's *Mulholland Drive* (indeed the next shot is a shot of the 'Mulholland Drive' road-sign – a shot reminiscent of the opening shot of Wilder's *Sunset Boulevard*.) The two pre-credit sign sequences fundamentally radicalise the whole horizon of the question of whether or not the cinematic journey upon *Mulholland Drive* is founded on an internal quest for identity.

Consider the opening Jitterbug sequence (the first pre-credit sequence/the first clue). We are presented with jitterbug dancers upon a flat monochrome field that is radically non-naturalistic.[15] What this frenetic dance seems to be signifying is a visual analogue to the problem of ceaselessly shifting identity – some of the figures themselves become hollow silhouettes through which we are able to glimpse the passing of other identities. Then, from

out of this frenetic dance three stable Figures emerge in a burst of chaotic iridescence to become illuminated in the foreground. These foregrounded Figures which emerge we recognise later as Betty, and the Mother/Father Figures (one of whom is referred to as Irene). The emergent three identities of Mother/Father/Child is a consistent motif in Lynch's films. The opening animated/live action sequence from Lynch's early film *The Grandmother* shows the emergence of the Mother/Father/Child from some unknown mechanism of reproductive forces that are reminiscent of Duchamp's mysterious sexual mechanism *The Large Glass*. Michel Chion in his study of Lynch's cinema has claimed that *The Grandmother* is a 'spontaneous eruption of the Lynchian problematic'.[16]

This emergent identity of Three Figures in both *The Grandmother* and *Mulholland Drive* is best understood as a radically non-real and unstable form of identity. They only represent a temporary state of becoming out of the frenetic and contained dance of shifting identities. Each of the becomings are to be understood as heterogeneous or radically different, and therefore imply an entirely different set of problems to be addressed. The problem in *The Grandmother*, as Michel Chion argues, seems to be that of the child's understanding of its emergent being and identity. Chion writes:

When the actions and images of *The Grandmother* are taken in succession, they form unusual cause and effect chains defying the first law of thermodynamics (according to which, nothing is lost and nothing is created). This law is internalised by all of us as we learn the cycles of nourishment and excretion, growth and death, transfers between inside and outside. But in Lynch's work there seems to be no link between food and growth...Things develop from the ground, grow, develop and divide without seeming to derive from anything but themselves...Everything is linked by a kind of magical

flux...The world of *The Grandmother* deals with organic and cosmic matters according to an 'electro-magical' type of logic...According to this logic everything occurs by abstract transmission.[17]

The emergence of Betty is similarly spontaneous, out of flux. This spontaneous emergence should be understood through the notion of the productive interstice. The spontaneous emergence of the three figures in *The Grandmother* is also this productive interstice, a purely heterogeneous event. The fact that this event is a pure singular intensity means that it drives forward a problematic that is internal to that original 'interstice'. The spontaneously emergent young boy finds himself inexplicably suffering abuse at the hands of his unloving parents, and is forced to have to literally grow a loving grandmother from a seed in the attic. The grandmother becomes his loving companion who exists in the parallel world of the attic. However, the boy's love for his grandmother turns out to be a kind of narcissistic self-love and is contaminated by that desire. Once this occurs the grandmother dies. There are many parallels to be drawn between *The Grandmother* and *Mulholland Drive*. The question in both films is who or what is provoking this spontaneous becoming of identity from the beginning. What is provoking this becoming *ex nihilo*? With regard to *Mulholland Drive* Lynch appears to provide an abstract sign as an answer to this particular problem, namely the second pre-credit sequence (the second clue).

This is the 'absent dreamer' sequence. We hear breathing (perhaps sleeping), and are presented with a camera shifting in extreme proximity, across a bed. What we are led to expect as the camera pans across the bed is a presentation of a sleeper or dreamer, but what is actually revealed is the absence of the sleeper or dreamer. It is as if the camera is the 'absent dreamer'. We plunge into the extreme proximity, depth and darkness of the pillow – and out of this we emerge onto *Mulholland Drive*. This

particular sequence shares many parallels with some of Lynch's other opening sequences, e.g. in *Eraserhead* we descend into a hole in an industrial container, in *Blue Velvet* we descend into the undergrowth, into the 'zone of the insects', in *Fire Walk With Me* we descend into a television screen, and *The Straight Story* begins with an unseen fall.

The second clue/sign in *Mulholland Drive* reveals that the zone of shifting and flowing identities from which a consistent congealed identity spontaneously emerges (emerging as it does in a pure conflagration of light and pure resonance of sound, accompanied by the forces of the Mother/Father) occurs within a radically disembodied and unspecific zone of becoming. The production of identity, figured initially through the spontaneous formation of Betty, is not actually taking place or occurring within the unconscious of any particular protagonist identified with any degree of certainty within the film. Rather, the entire fabric of the film itself should be understood as a process of the production of the question of identity undertaken by a pure outside thought. The specific process undertaken by this exteriority to produce a stable identity takes a very irrational path indeed.

In the latter part of the film, where we seem to be presented with the drab underside of the fantasised imaginings pertaining to Betty and Rita, (where it becomes a matter of Diane and Camilla) there is a further addition to the fabric of the dream logic already unfolded. It should not be read as some type or species of reality to which the first part of the film was simply a dream type interpretation. Rather this latter section represents the result of everything that has occurred so far. What unfolds between Diane and Rita becomes unsustainable, and the alien thinker is forced to attempt another more sustainable mode. This attempt begins to look like reality more than a hyperbolic fantasy, but is never actually so. If both of the fantasy characters of Betty & Rita are conceived as being merely expressions of an

identity in search of itself then the moment in which Diane and Rita become lovers represents an interstice from which an irrational solution must emerge. It is a self-circuit infected by desire, as it had been in *The Grandmother*. They are driven to *club silencio*, where significant realisations concerning the nature of the fabric within which they are caught up become apparent to them. 'It is all an illusion'. However, figured in *club silencio* is a kind of double presentation of the nature of the illusion. What we are presented with is not just a visual figuration and dramatisation of the nature of the fantasy which a 'real' Diane Selwyn has fabricated, rather, we should read the scenes at *club silencio* as an abstract sign of what is occurring throughout the entire fabric of the film, and in this respect its double-sided aspect makes more sense.

The first scene at *club silencio* involving the Mephistopheles character is exaggerated and theatrical and fantastic; the second, involving the singer Rebecca del Rio, is far more realistic, invested with a sense of pathos and tragedy, yet it is still an illusion. Rebecca del Rio's song of lost love, a Spanish version of Roy Orbison's *Crying*, is still only a tape recording and not real. What occurs at *club silencio* suggests that we should treat the double narrative in the film as in fact two fragments or interstices within the expression of the entire fabric of the film. It is clear that we should treat both elements as illusory and not just the obviously fantastic and hallucinatory first element. If the film's compositional principles are understood through the theoretical notions of interstice and creative differential addition then it should not be understood as two parallel structures, with one Real element functioning to interpret the other fantasy element as if through dream logic. The radicality of *Mulholland Drive* as a work of sublime cinema lies in the extent to which its entire fabric can be read as the emergent fragmented dream logic in search of a stable and manifest identity predicated upon the spontaneous interstitial becoming of a identifiable character that becomes

dispersed, fragmented and lost. The film ends with this figurated identity in the shape of Diane Selwyn becoming completely dissipated, with the parent figures becoming menacing and monstrous figures driving her to suicide. After her suicide we see the face of the man behind Winkies, 'There's a man in the back of this place, he's the one that's been doing it.'

The film becomes realised as the product of an alien thought, imposing a fragmentary dream logic in search of an identity. According to Wittgenstein that is precisely how dreams function – they are the fragments that solicit unity and identity in the form of a coherent story. Yet the dream can never be that unity and coherent story.

As these close examinations of two of Lynch's films have tried to reveal, his work solicits a ceaseless activity of thought, which is structurally open-ended and fragmentary. His entire counter-sense cinema has to be approached through an understanding of the sublime nature of the dream fragment, the dream logic and the ongoing solicitation of an energised and intensive activity of thought on the part of us, the spectators.

If we are indeed not yet thinking, but have the capacity for thought (a thought always yet to come), can the same not be said for our capacity to dream? Are we all capable of dreaming? If we possess such a capacity do some of our dreams express a collective aspiration for reaching a realm of truth beyond the surface of our everyday thinking? Is it possible that our dreams are really an expression of our forgotten capacity to think? Do they express our longing for something lost, not just in the passing of time, but as a symptom of the cultural suspension of time? Perhaps my dreams think for me what I am no longer able to think when awake. No matter how cognitively insensitive we might have become, the intensity of such dreams affect our waking life – to transform, alter and energise it. From dream to dream there is the possibility for us to wake up more and more conscious. However, more often than not we forget them and

move on. The counter-sense cinema of David Lynch harnesses the transformative energies of the dream in the effort to bring us into closer contact with the mystery of something always greater than we are. For Lynch this is the thinker within the thinker, the larger 'I' that dwells within our quotidian selves. There is always someone else within each of us, someone greater, more mysterious, more powerful, perhaps darker, perhaps nobler, who pushes us to grow in different ways and to become aware of the world as a far stranger, more dynamic and larger field than our everyday common-sense would permit. Lynch's cinematic therapy is aimed at liberating us from the cognitive restraints of our everyday selves and confronts us with the hidden, unconscious and larger self that inhabits us. He celebrates the affective derangement that results from a particular form of cinema, a form which allows the larger 'I' to cross the threshold of consciousness and circulate more freely. The dynamic and intense energy of this cognitive release, triggered by his peculiarly deranged form of counter-sense cinema, reminds us of the essential vitalism of life that we are all an expression of and were once all very close to, a vitalism that has become fatally eroded, nullified and forgotten. It seems to me as if all of Lynch's counter-sense films are asking these questions. They harness dream energy, and use it to provoke our thought, to awaken and activate the sleeper.

Werner Herzog: Documentary and the Art of Collective Dreaming

I know that by making a clear distinction between 'fact' and 'truth' in my films, I am able to penetrate into a deeper stratum of truth most films do not even notice. The deep inner truth inherent in cinema can be discovered only by not being bureaucratically, politically and mathematically correct. In other words, I start to invent and play with the 'facts' as we know them. Through invention, through imagination, through fabrication, I become more truthful than the little bureaucrats. I've always made it very clear that for the sake of a deeper truth, a stratum of very deep truth in movies, you have to be inventive, you have to be imaginative. I'm after something deeper. I call it the 'ecstatic truth' – the 'ecstasy of truth'.

Werner Herzog

Life Without Fire

Werner Herzog's 1991 film *Lessons of Darkness*, made in collaboration with the British cinematographer Paul Berriff, was shot in Kuwait during the aftermath of the first Gulf War. It opens with apocalyptic lines drawn from Blaise Pascal which effectively set much of the tone for what follows: 'The collapse of the stellar universe will occur – like creation – in grandiose splendour.' On paper at least, the film is a documentary about the burning oil fields set on fire by retreating Iraqi troops during the last days of the Gulf War, the environmental devastation they caused and the extraordinarily technical feat of extinguishing them. Yet what actually emerges is less a documentary about fire-fighting in post-war Kuwait, than a full-scale apocalyptic vision of hell on

earth – or, as Herzog called it, 'a requiem for an inhabitable planet.' Herzog creates a far more potent portrait of the demonic elements of war than most films. The dark horror that he conveys through his images of a man-made Hell is enhanced by its unspeakable nature – the spectacle 'documented' by this film is beyond human articulation. Interspersed with the deafening roar from the oil fires, which drown out occasional shouts from the fire-fighters, are pieces of elegiac orchestral music from Mahler, Prokofiev, Verdi, Wagner, and Arvo Pärt. Little or no conventional commentary is attached to the imagery, and little or no relevant contextual information is provided by Herzog. There is no footage to establish the actual location or timeframe, apart from some brief spectral night-vision footage of the bombings shot during the opening days of the war. This narrative subtraction intensifies the apocalyptic effect of depicting the devastated landscape. Herzog remarks that:

> After the first war in Iraq, as the oil fields burned in Kuwait, the media—and here I mean television in particular—was in no position to show what was, beyond being a war crime, an event of cosmic dimensions, a crime against creation itself. There is not a single frame in *Lessons of Darkness* in which you can recognize our planet; for this reason the film is labelled 'science fiction,' as if it could only have been shot in a distant galaxy, hostile to life.[1]

This is a cinematic pilgrimage to hell where a planet (earth), shattered by war, has unleashed a plague of oil that has overtaken all that is living, corrupted the minds of its inhabitants with greed, and killed all hope for future growth of vegetation. Instead of a landscape marked by lakes of water, there are only lakes of black oil that, in their deception, reflect the sky. If water is life, then this oil is death. Herzog provides a sparse voiceover that interprets the imagery out of its straightforward

documentary context, and into the realm of poetic fiction. Indeed, the bizarre and otherworldly footage demands such a poetic approach. After the quotation from Pascal, his opening narration begins with: 'A planet in our solar system; wide mountain ranges, clouds, the land shrouded in mist'. Throughout the rest of the film his narrative position is detached, abstract and bemused, as if he were viewing footage taken from an alien planet. He fashions a poetic fiction that portrays a more universal form of damnation than a mere documentary about Kuwait in 1991 would suggest. In this film, the demonic forces that lurk inside the hearts of men appear to be beyond civilized understanding or rational control. These issues of cruelty and madness are as elemental as fire itself.

Herzog's quest for new images in cinema has rarely been darker than it is in *Lessons of Darkness*, and almost certainly never as cautionary. The slow accumulation of images, music and voice-over builds to an intense, abstract and poetic meditation on warfare and catastrophe. In one his most recent documentary films, *The Cave of Forgotten Dreams* (2011), the tone could scarcely be more different. Yet its visionary quest remains entirely consonant with that of *Lessons of Darkness*. In both Herzog is more concerned with elaborating an ecstatic spiritual allegory rather than merely cinematically reproducing the surface facts of the world. In this new film Herzog takes us into the recently discovered Chauvet Cave in south-west France, containing some of the oldest known cave paintings. These paintings, dated to before 32000 B.C., are extraordinarily well preserved. In the immediacy of their presence we are confronted with a vertiginous sense of our collective past and our forgotten dreams. As the camera pans across these exquisite works of art, perfectly blended with the suggestive topography of the cave (captured by Herzog's use of 3D cameras), we are taken back to a more primal relationship with nature and animality, to the profound origin of art and its function. In certain works there is the suggestion of an

effort to express animal movement, with superimposed painted animals flickering under lamplight, like primitive animated figures. Herzog is keen to point out that here one may discern the earliest form of cinema. His recording of these ancient paintings demonstrates the extent to which they were stylistic experiments in capturing the animated flow of life outside the cave. In order to convey the dynamism and plenitude of natural animal life the painter is shown to have negotiated between the suggestive contours of the cave wall. The technique of rendering recognisable animal forms is the result of a subtle blend of representational similitude and their own imagination. Despite the interpretative gulf that exists between these works and ourselves, they seem to express a nameless spiritual transcendence figured through representations of material animality, an ecstatic journey beyond the confines of the human animal. Borderlines, thresholds and hybrid states are gloriously played out across the shifting topology of the cave. For Herzog this remains consonant with the aims of all art, and for him of course, the art of cinema. These paintings express our oldest collective dreams, the most ancient exploration and expression of the mystery of our own humanity and our own place within nature all around us. In this sense, *The Cave of Forgotten Dreams* is a paradigmatic example of Herzog's documentary filmmaking as a fabulated attempt to provide a collective chronicle of our inner spiritual lives, the mystery of our inner world, our struggle to relate to nature, and our attempts to transcend our physical limits.

Ecstatic Truth and Powers of the False

Herzog first came to prominence in the late 1960s, when he, along with other emergent directors such as Rainer Fassbinder, Volker Schlondorff and Wim Wenders, became known as one of the key filmmakers associated with New German Cinema. Along with producing a number of highly original and ambitious feature films such as *Even Dwarfs Started Small* (1970), *Aquirre, the Wrath*

of God (1972), *The Enigma of Kaspar Hauser* (1974), *Heart of Glass* (1976), *Stroszek* (1977), *Nosferatu the Vampyre* (1979), *Fitzcarraldo* (1982) and *My Son, My Son, What Have Ye Done* (2009), Herzog has simultaneously produced a distinctive body of documentary work which in recent years has generated a great deal of critical acclaim, particularly his recent films *Grizzly Man* (2005) and *Encounters at the End of the World* (2007). It is his documentary filmmaking, and its capacity to re-enchant us with the world through a reconfigured notion of truth, that is the main focus of this chapter.

Just as Lynch's films strive to capture and present the strange power of the dream within a unique form of counter-sense cinema, Herzog has pursued a no less intense effort to chronicle the mysterious interior of the human. All of his films, both feature and documentary, explore the mystery of our inner life. They strive to express our collective dreams, and perform an ecstatic act of re-enchantment upon the world. For Herzog, the filmmaker's quest entails the search for images capable of illuminating the on-going mysteries of human existence, and to actively resist falling into cliché.[2] Herzog tries to move us beyond representational mirroring of the flattened surface of the world and ourselves. He pursues an alternative, visionary cinema expressing a deeper truth than that contained in the quotidian surfaces of capitalist realism; to elaborate a cinematic tenebrism of the human spirit, presenting all that we have been and all that we may still become. Cinema is a uniquely *affective* way of capturing and preserving our experience and our collective dreams, translating them into *affective* cinematic images. To express an inner chronicle of the human through film is an artistic duty. In interviews, Herzog has claimed that all of the protagonists in his films (both documentaries and fictional features) are sympathetic points of self-reference, as if he has been gradually filming his own life. The inability to fully communicate the interiority of their existence reflects Herzog's

own struggle to find 'a new grammar of images' that is capable of cinematically communicating a more profound sense of the truth of being a human being.

In documentaries such as *Land of Silence and Darkness* (1971), *Fata Morgana* (1972),[3] *The Great Ecstasy of Woodcarver Steiner* (1974), *Echoes from a Sombre Empire* (1990), *Lessons of Darkness* (1992), *Wild Blue Yonder* (2005), *Grizzly Man* (2005) and *Encounters at the End of the World* (2007) reality becomes heightened and intensified to the point of fiction. Whether it is the lives of the deaf-mute or those living in the magnificent isolated splendour of Antarctica, there is a consistent effort to confront that which is beyond our understanding, to try and make visible certain truths that are beyond the visible, to reveal the least understood truths of the human being. The observational dimensions associated with familiar orthodox documentary filmmaking are often associated with the 'facts' of surface appearance, rather than the occluded depths of truth. There is an epistemology of the quotidian rather than the poetic, a taxonomy of measurable 'facts' rather than 'truths'. Herzog constructs an original cinematic identity as a visual cartographer of the invisible, a cinematic alchemist visualising a psychological or spiritual interiority. These are truths of all shades, both dark and light. However such truths cannot be merely achieved through simple reproduction of what *is* – they have to be *created* through an act of productive unveiling. Earlier, when discussing his film *Lessons of Darkness*, I noted the opening quotation from Blaise Pascal which Herzog uses: 'The collapse of the stellar universe will occur – like creation – in grandiose splendour'. However, what I failed to mention there was that this attribution is entirely apocryphal; the text was fabricated by Herzog for the film and chosen, like the music, to give the film a certain tone and mood. Herzog writes:

Pascal himself could not have said it better. Why am I doing this, you might ask? The reason is simple and comes not from

theoretical, but rather from practical, considerations. With this quotation as a prefix I elevate the spectator, before he has even seen the first frame, to a high level, from which to enter the film. And I, the author of the film, do not let him descend from this height until it is over. Only in this state of sublimity does something deeper become possible, a kind of truth that is the enemy of the merely factual. Ecstatic truth, I call it.[4]

Truth for Herzog is never something static, atemporal or eternal. It is never simply a question of literally reproducing observable 'facts'. All of his work is driven by the desire to provoke thought by violently unhinging it from nihilistic adherence to a singular fixed truth and propelling into deeper uncharted territory. Despite all too often adhering to the orthodox regime of fixed truth, he has faith in the idea that cinema is capable of subtly destroying the dominant idea of a singular invariable realm of reality through the deliberate creation of ambiguity. By establishing an oscillation between fiction and truth, the filmmaker is able to reintroduce the idea of an unstable temporal order where things resembling truth are more difficult to come by. In this way cinema produces a new understanding of truth as the fabrication and unveiling of a myth; it produces 'ecstatic truth'.

In 'On the Absolute, the Sublime, and Ecstatic Truth', originally delivered as a speech in Milano, Italy in 1992, and in his shorter aphoristic 'Minnesota Declaration' in 1999, Herzog laid out the principles of his personal documentary style, distinguishing between the mundane facts of the surface and a far deeper, sublime, ecstatic truth that can only be reached 'through fabrication and imagination and stylization'.[5] To better understand how falsity becomes a power of ecstatic truth, we need to first revisit the question as to why the desire for truth emerged in classic forms of cinema, and why it persists in the mainstream today. In order to do this it is worth recalling Stanley Cavell's argument, which I outlined in the opening chapter of this book,

regarding the invention of photography and film. Both emerged as a response to a peculiarly post-Enlightenment desire for realism. More specifically, they emerged from a desire for a deeper metaphysical contact with an invariable reality from which we had become increasingly estranged.

> Photography satisfied ... the human wish to escape subjectivity and metaphysical isolation – a wish for the power to reach this world, having for so long tried, at last hopelessly, to manifest fidelity to another.[6]

According to Cavell, religious fidelity to a fixed metaphysical ideal guaranteed a powerful sense of social and collective identity. During the Enlightenment, however, old religious certainties were eroded, resulting in the modern subject of scientific empiricism becoming progressively detached from any collective grounding commitment, and increasingly alienated and confined within itself. Since the living notion of God retreated and no longer anchored a collective static meaning in the world, the epistemological and moral responsibility for discerning meaning from nature fell more and more upon the subject alone. This confinement to subjectivity led to an insoluble epistemological crisis where humanity and nature became alienated from one another. Photography and film respond directly to this metaphysical dilemma, since they operate as a type of mechanical reconciliation device for the alienated subject. They appeal to a metaphysical need in the subject, i.e. to view the world freed from confinement within its own subjectivity and to see it as it actually is, anonymously and unseen. The subject desires to regain contact with the world through perceptions of it which are analogous to the level of contact it may have once felt, as part of a collective, towards the transcendental religious world in the pre-Enlightenment era. By mechanically producing analogical images of the world, photography and film displaced

the solipsistic sovereignty of subjective perception; in doing so it offered a renewed opportunity for reconnecting to the reality of the world. In the analogical transfer of photography and film, humanity and the world are cast into an ontological continuum, becoming integrated into a shared duration. Humanity and the world objectively appear to share the same ontological substance and to have the same epistemological nature. Photography and film appear to offer us a means for reconnecting back to an invariable reality.

Despite recognising the significance of the post-Enlightenment subject's anxiety, Nietzsche recognised that for the world to be 'true', or for it to be subject to a 'truthful' description of any kind (as suggested by film and photography), it would have to be something essentially static, fixed and unchanging. He opposed this fixed mechanistic world to a world of continual change composed of a multiplicity of forces and of constant becoming in which relations of identity are in flux. Those who uphold a singular 'true world' are in thrall to what Nietzsche calls a moral-optical illusion. They activate a negative will which views the world as an illusory appearance, positing a supersensible and ideal world, a true and a good world, that bestows a stable order on life from a transcendent perspective (i.e. from a position somehow outside of life). For Nietzsche this is a moral rather than an epistemological perspective: the goodness of *knowledge* is opposed to the inherent falsity of *life*. The truth-seeker wants to 'correct' life by making it conform to an a-temporal, systematic and transcendent image of thought. In doing so he annihilates life in an ideal image .Truth and truth-seekers are the avatars of nihilism, responsible for denying and mutilating life as it is. The pursuit of a singular ideal truth is the manifestation of a will to depreciate life, to oppose life to life. It is a sign of decadence and life in decline. And this is no less the case with mainstream cinema's continued fidelity to an outmoded, clichéd and barren attachment to the familiar imper-

ative of reproducing an invariable present.

Inspired by Nietzsche, Deleuze argues that 'the true world' does not exist, and, if it did, would be 'inaccessible, impossible to describe, and, if it could be described, would be useless, super-fluous'[7]. If a complete description of this world were actually possible then life itself would disappear into static, lifeless signs. The real task, one taken up in the cinema by directors such as Herzog, is how to restore life to our thought, to find out how it can be made more dynamically responsive to the actual forces of life. This post-Nietzschean quest is evacuated of any theological content. It is engaged in a material politics of resistance to the present, it cultivates new and invigorated forms of affirmative faith and hope in this world as it is. This is the significance of what Nietzsche called the affirmative tendency of the creative artist, where the play of appearance is valued much more highly than the singular pursuit of the truth of reality. In this play the powers of the false are harnessed and utilised as a way of describing the affirmative mode of thought and being, or as Deleuze puts it, 'a will to falsehood' is activated. This is a creative artistic will which realises itself not in the accomplished image of art but through the creative act itself (i.e. through its vital becoming). The falsity associated with the creative act cannot be consigned to being a mistake: it is the vital power that renders truth un-decidable by introducing the dynamic and plural temporality of becoming back into the static, a-temporal and reified true world. What is achieved is a new metaphysics of truth through the introduction of the powers of the false. Deleuze, writing about Nietzsche, says:

A higher power of the false, a quality through which the whole of life and its particularity is affirmed and has become active. To affirm is to unburden: not to load life with the weight of higher values, but to create new values which are those of life, which make life light and active. There is

creation, properly speaking, only insofar as we make use of excess in order to invent new forms of life rather than separating life from what it can do.[8]

In spite of the fact that it operates under a metaphysical illusion regarding the invariability of the truth of the present, cinema has the potential to invent and liberate forces of life through its explorations of the powers of the false and the introduction of non-chronological time. Forms of cinema are possible where characters or subjects are deliberately constructed as the site of an oscillation between the 'real' and the 'fictional', the past and the present. The character depicted has aspects which are recognisably aligned with the established order of truth and the normative chronology of time, yet display a capacity for infidelity, fabulation and being unhinged from time (think here of the New Wave work of Alain Resnais, Chris Marker, Michelangelo Antonioni and Jean-Luc Godard in the 1960s[9]). The indecisive oscillation sets up a disruption within the static fabric of organic truth usually at play in cinema. Through this strategic disruption, the filmmaker is able to reintroduce dynamic and unsettled temporality into film. We no longer occupy familiar chronological time. Anomalies and aporias become the essential compositional elements within the film.[10] In such films, Deleuze claims, 'concrete space ceases to be organised according to tensions and resolutions of tension, according to goals, obstacles, means, or even detours ... this is a type of space where the connecting of parts is not predetermined but can take place in many ways...we have a chronic non-chronological time which produces movements necessarily 'abnormal', essentially 'false'.'[11] Such films pose inexplicable differences to the time of the present. They posit a series of alternatives, are caught between true and false, to the time of the past. 'The truthful man dies, every model of truth collapses, in favour of the new narrative.'[12] These new types of film no longer operate within

the classical regime of representation and truth in which there is either invariable form or variable point of view onto a given and established form. There is only an immanent 'point of view', or, to put it another way, a viewpoint which is absolutely identical to the reality being viewed. Reality is subjected to essential transformations by the ambiguous and oscillating shifts in point of view. In this respect Herzog's dystopian sci-fi documentary *Lessons of Darkness* is a paradigmatic example. Throughout the film truth is not something invariable to be achieved, formed or reproduced, but is something to be *created*. Truth is something intensely affective. There is no other truth than the creation of this new perspectivism. Through such films cinema can become a free, indirect discourse, operating in reality and producing its own truth. It is forgery. The Truth, a poetic truth which is the enemy of fact, becomes possible. It is this that Herzog calls ecstatic truth.

How can cinema be utilised as a means for raising oneself out of the moral-optical illusion of a static regime of truth? The fact that so much of cinema remains nihilistically mired within it accounts for so much of its continued stupidity, and monotony. We live amidst the ossified remains of that regime, where possibilities for evading it appear slim indeed. The affirmative role of cinema remains both poetic and ecstatic – not merely a stylistic ornament designed to accompany our lives and to offer excitement, amusement and distraction from our everyday existence. It offers us a way out. It can offer ecstatic extraction from the conditions of the present and transport us into an altered realm of truth. A realm in which the truth of our existence becomes more fluid, dynamic and open. Herzog's concept of cinematic ecstasy becomes increasingly important when one considers the sheer mass of quotidian banality that passes for cinema most of the time. For Herzog the cinema should offer us, the spectator, a chance to step outside of ourselves, outside what we already recognise to be true or real. It transports us to a place where we can contemplate and reflect upon our own nature.

Cinematic ecstasy involves affective intensity, flights of imagination, poetic connections, wordless contemplation, joy and wonder.

A Visionary Poetics

Herzog's whole conception of cinema is predicated upon a different, liberating and optimistic, sense of human being and possibility. The human being is always-already fundamentally structured as an ecstatic being, always ahead and outside of itself, always striving beyond the limitations that at any point in time may confine it (physically, socially, culturally, politically). We are restless, imaginative and transcendent beings, evidenced by some of the most ancient depictions of our collective dreams for dynamic transformation and becoming which Herzog documents in *The Cave of Forgotten Dreams*. It is as if he is saying 'Look! Look what we used to be! Look what we have become!' A cinema of ecstatic truth reawakens this ancient sense of ourselves, our vital capacity to confront, challenge, resist, transform and create.

Herzog's work revolves around two obsessive themes. Most of his films involve a single human protagonist (e.g. Aguirre, Steiner, Fitzcarraldo, Stroszek, Dengler, Treadwell) who is larger than life and frequents a milieu that is itself larger than life (e.g. the excessive and sublime landscapes of the jungle, the desert, the mountains, the sea, etc.). This protagonist dreams up an action that is as great in scale as the milieu itself (e.g. to discover the mythical city of El Dorado, to establish an opera house in the Peruvian jungle, to travel to the mythical Land of Opportunity that is the United States, to fly, or to live out one's life among wild bears). This is the first of Herzog's great themes: an action undertaken that is not actually required by the situation the protagonist is in; a crazy enterprise born in the fevered mind of the visionary as part of an effort to challenge the overwhelming scale of nature. This sublime action, more often than not,

engenders another action, which is heroic in nature. The protagonist confronts the enormity of the milieu, which threatens to engulf, overwhelm or destroy him/her. Through the sublime and heroic action the Herzogian protagonist is 'penetrating the impenetrable, breaching the unbreachable'.[13] These two interrelated themes are present in some of Herzog's greatest documentaries, such as his early masterpieces *Land of Silence and Darkness* and *The Great Ecstasy of Woodcarver Steiner*, and notable later films such as *Little Dieter Needs to Fly*, *Wings of Hope* and *The White Diamond*. There is a remarkable consistency of vision across these films, which Deleuze articulates beautifully: 'There is thus both a hallucinatory dimension, where the acting spirit raises itself to boundlessness in nature and a hypnotic dimension where the spirit runs up against the limits which Nature opposes to it.'[14]

The co-existence of these two dimensions is often a crucial aspect of Herzog's feature films. Yet, I wish to maintain the focus upon his documentary work in order to elicit the visionary potential of a Herzog's unique cinematic poetics. Herzog describes two of his early documentaries, *Land of Silence and Darkness* (1971) and *The Great Ecstasy of Woodcarver Steiner* (1974), as amongst his most important films. Important in that they not only express hallucinatory and hypnotic dimensions, but also embody the foundational principles of 'ecstatic truth'. *Land of Silence and Darkness* was Werner Herzog's first feature-length documentary, made in 1971, tells the story of Fini Straubinger, at the time a leader of, and advocate for, the deaf and blind in Germany. Straubinger developed a tactile form of communication which she uses to talk with and teach some other deaf-blind people who have language-learning capacity. Like many of his other characters, Herzog portrays Fini and the other deaf-mute people as lonely outsiders isolated from society, suffering from an inability to communicate their existence.

It is a film driven by an obsessive compulsion to communicate. It touches upon the deepest question of what it means to

be human, and this is central to its enduring mystery, beauty and power. The film begins with Fini communicating with other deaf-blind individuals who have a comparable grasp of the tactile language, many of whom become deaf-blind later in life. There are powerful scenes in which they share poems at Fini's birthday party; they take a first aircraft flight, a visit to a botanical garden and a zoo. However, the film transports us from this realm of silence and darkness inexorably towards a far stranger and mysterious one by introducing those who have been deaf-blind from birth. In contrast to Fini and her friends, these individuals are locked into a terrible isolation with little or no way of communicating their human interiority. Herzog shows some of the ways these children are taught to communicate, but we are told that it impossible for them to communicate abstract concepts such as 'good', 'bad', 'love' and 'happiness'. Amidst this despair and loneliness Fini is filmed by Herzog reaching out to these children, to touch and to try and communicate with them. Her efforts at communication become transcendent and transformative acts. The film becomes a story of communicating the bare presence of others to individuals trapped in the most complete form of loneliness, a dignified communion of lonely souls. Herzog said of it: 'In the film one finds the most radical and absolute human dignity, human suffering stripped bare'[15].

At the heart of the film is a paradoxical tension arises from the attempt to use the medium of film – a medium that appears to be limited to communicating through the senses of sound and sight – to document people who can neither see nor hear and their efforts to communicate with others and the world around them. Noël Carroll writes on Herzog:

Land of Silence and Darkness repeatedly invites us to contemplate the indescribability and inexpressibility of the experience of the deaf-blind. For though language functions well enough – both referentially and socially – throughout the

film, the alien context in which it is used makes us strongly aware of the presence of a realm of experience effectively beyond the reach of language. That is, language remains serviceable between us and the deaf-blind, but when it comes to the thoughts and feelings, or better, the associations attending such discourse, we sense a radical problem of translation.[16]

The sensual form of communication at the heart of the film, unlocking the deaf-blind from their strange loneliness, provokes Herzog to try and discover a 'haptic'[17] form of cinema, a cinema capable of turning the eye into an organ of touch as well as sight. It is a cinema that reveals deeply spiritual and profound sensations. Arguably, the most powerful mode of spiritual communication in the film comes from those non-discursive touches that create a sensory communion that is more immediate and less ordered, for example the scene of the young deaf-blind boy Harald immersed in the pure sensual delight of the shower, or Fini's remarkable tactile interactions with a young deaf-blind man Vladimir and her introduction of the radio which he grasps to his chest as if it were a living thing, or the final sequence with Herr Fleischmann, the deaf man who became blind when he was thirty and lived for six years in a cowshed.[18] When talking of this final sequence during an interview Herzog said:

Remember the shot when he walks over and touches the tree? It is absolutely unforgettable, a whole human drama played out in two minutes. If you had not watched the rest of the film and tuned in just at that point you would just think, 'Well, there's a man who is embracing a tree.' What is happening on *screen at that* point *is* very simple, but it requires the additional one and a half hours of preceding scenes to make the audience receptive and sensitive enough to be able to understand that this is one of the deepest moments you can ever encounter.'[19]

To get a sense of how ecstatic truth operates in this film we can focus on a number of things which occur there. During one sequence of the film, Fini, who became deaf and blind in later life, recalls a childhood memory of watching men fly in the air at a ski-jumping competition. As she speaks footage of a ski-jumper against the backdrop of the sky is inserted by Herzog. This recollection occurs four years before Herzog goes on to make *The Great Ecstasy of the Woodcarver Steiner* about the Swiss champion ski-jumper Walter Steiner. Herzog has subsequently acknowledged that Fini's memory of ski-jumpers was entirely fabricated from out of Herzog's own memory, and that he gave Fini the sentence to speak, which he says she immediately understood the reason why. This scene speaks of Herzog's own attitudes towards ski-jumpers[20] and his intuition that a sensuous link could be formed between Fini and them, and, equally important, it forges a powerful symbolic link between Fini and Herzog. An almost mythical link is established between the two that remains significant for the rest of Herzog's career. Of ski-jumpers Herzog has said: 'Ski-jumping is not just an athletic pursuit, it is something very spiritual too, a question of how to master the fear of death and isolation. It is as if they are flying into the deepest, darkest abyss there is. These are men who step outside all that we are as human beings, and overcoming this mortal fear, the deep anxiety these men go through, this is what is so striking about ski-jumpers.' By fabricating Fini's memory of ski-jumpers Herzog is intuitively linking a series of images of ski-jumpers together in order to suggest a very deep, almost spiritual, truth about Fini's character. Herzog himself says – 'Very early on, I had the feeling that only through invention and stylization would I reach a very deep truth about a character, even in a documentary. So in this case it is made up. But as much as it is made up, it also points to her deepest truth'. As Carroll writes:

In several ways, *Land of Silence and Darkness* is the emblematic

Herzog film. For in underscoring the inaccessibility of the feelings and experiences of the deaf-blind, the film presents these figures as paradigmatic Herzog heroes. These characters are moved by inner forces that for Herzog remain inexplicable, unnameable, and indescribable. The inscrutability of the springs that move them erects a certain affective distance – a kind of obdurate clarity – between us and them. Such figures are virtually canonized by Herzog for the uniqueness and the inaccessibility of their passions and their inner life.[21]

Through an intuitive act of ecstatic truth, Herzog establishes a deep poetic communion between Fini Straubinger and himself as a filmmaker. Fini becomes emblematic of the human struggle to communicate ineffable qualities associated with being alive. Herzog has her voice something spiritually significant for him, ski-jumping, in such a way that it sets the philosophical tone for most, if not all, of Herzog's subsequent work.

The Great Ecstasy of the Woodcarver Steiner (1974), which Herzog also regards as one of his most important works, is a documentary about the Swiss ski-jumper Walter Steiner's death-defying and record-breaking leaps during the championships in Planica, Yugoslavia in March 1974. The documentary material on Steiner is transformed into a powerful meditation upon the capacity to ecstatically transcend the limitations of the human condition.[22] As Herzog once said: 'They dream they can fly and want to step into this ecstasy which pushes against the laws of nature.'[23] From its remarkable opening sequence, in which we see a ski 'flight' played to us at 1/20th speed set to the hypnotic tones of regular collaborator Popol Vuh we immediately become aware that this is much more than a mere documentary. The visionary quality of the work is immediately established in the opening shot of a ski-jumper (later identified as Walter Steiner) launching into the air. Interestingly, Herzog just depicts the

launch, showing us the ski-jumper's expression, reserving footage of the all-too-often catastrophic landings for later in the film.

> You can see it in the faces of the flyers in the film as they sweep past the camera, mouths agape, these incredible expressions on their faces. Most of them cannot fly without their mouths open, something which gives such a beautiful ecstatic feel to the whole movement.[24]

Herzog makes no real attempt to contextualise the event of ski-jumping for us, or even attempt to elaborate a meaningful psychological explanation of those individuals who participate. Such expectations reside wholly within the confines of the all-too prevalent regime of the 'factual'. He relies upon super-slow camera footage of the skiers in mid-flight (in a state of ecstasy, mouths open), and their often violent and catastrophic landings, accompanied with one of Popul Vuh's most striking soundtracks. The imagery of open-mouthed ski-flyers in mid air aiming towards the vast white space of the landing area captures the sheer ecstasy that the competitors feel once they have achieved the gracefulness of flight. This documentary miraculously expresses moments of genuine euphoria and weaves a dreamlike mythology about those who repeatedly attempt to transcend the limits of the human. Steiner is an enigmatic and reclusive woodcarver driven by a mysterious obsession to fly, to transcend the limitations of the human, to go further and further, risking death, to experience an ecstatic transfiguration at the very threshold of the human.

At the very end of the film Herzog elicits a rare personal story from Steiner about a raven that he once befriended as a child. Steiner recounts how the raven was his only friend. He describes how he reared it on milk and bread. Both he and the raven were embarrassed by their friendship, so the raven would wait for him

far away from his school, and when all the other children were gone it would fly on to his shoulder and together they would walk through the forest. However, the raven began to lose its feathers, probably due to its diet of milk and bread. The other ravens thought it an outsider and started to attack it, pecking it almost to death. They injured it so badly that Steiner had to shoot it. 'It was torture to see him being harried by his own kind because he couldn't fly any more,' he explains. This story is then followed by a beautiful quote from Steiner that is overlaid over slow motion footage of him landing in the bleak wilderness. Steiner is shown launching himself into the air, just as at the beginning of the film, accompanied by the music of Popul Vuh, except this time the camera tracks him through the air as he glides majestically and lands perfectly with his arms outstretched, caught in a moment of religious ecstasy. As with Fini's memory in *Land of Silence and Darkness*, the text is not Steiners own, but drawn from the Swiss writer Robert Walser. Herzog introduces this poetic quote after Steiner's story of the raven since he believes it says something absolutely essential about Steiner, his ecstasy and his solitude.

> I should be all alone in this world
> Me, Steiner and no other living being.
> No sun, no culture; I, naked on a high rock
> No storm, no snow, no banks, no money
> No time and no breath.
> Then, finally, I would not be afraid any more.

This sequence, unequalled in any of Herzog's subsequent work, draws the singular enigma that is Walter Steiner back into Herzog's own imagination and the collective human realm. Throughout the film Herzog presents Steiner as an enigmatic and taciturn figure, driven remorselessly by an almost spiritual desire to fly further than any other human being before him. Steiner's

ecstatic quest is only revealed through his repeated physical exertions. His refusal to articulate, on camera, his own interiority heightens the poetic mystery surrounding him. We are brought into the company of a mystic traveller willing to traverse the abyss for us; Herzog forces his ecstatic drive into this realm. Steiner's desire to extract himself from the confines of the ordinary world and put himself into a state of spiritual transcendence speaks to a deep human desire to transcend the limitations imposed upon us by the time in which we live, our own bodies and our own cultures. It provides an affective instance of the powerful shared yearning we all have for ecstatic transfiguration; our desire to be reawakened. Steiner's dream is an individual dream, yet it is a collective dream – a dream that he can enact through ever more extraordinary feats of ski-jumping. Herzog, adopting the role of communicator à la Fini Straubinger (an identity established through the fabricated shared memory of ski-jumping), becomes the mythical and poetic translator of Steiner's innermost dreams and yearnings. To translate Steiner's spiritual quest, he fashions a cinematic language that is simultaneously visual, tactile and affective. Through this he is able to renders Steiner's profound solitude into something that can be shared by us all.

As majestic as the hypnotic airborne sojourns are, Steiner and his fellow ski-jumpers repeatedly crash to earth. The real danger of serious injury, or even death, accompanies the ecstatic flights, highlighting the heroism of their solitary quest for flight and their drive to defy gravity. This disastrous fall to earth re-emerges as a major theme later in Herzog's career, examined in three of his documentaries: *Little Dieter Needs to Fly* (1997), *Wings of Hope* (2000) and *The White Diamond* (2004).

All three involve extensive use of ecstatic truth to examine the nature of the protagonists and their remarkable stories. *Little Dieter Needs to Fly* tells the story of Dieter Dengler. Born in Germany in 1938, some of his earliest memories were of Allied

aircraft bombing his small village in the Black Forest. He recalls how one bomber flew close to his house, firing its guns as it passed the window where he was standing. For a split second his eyes locked with the pilot's. Rather than feeling fear, he was transfixed: it was as if he had seen some strange and almighty being fly down from the clouds, and from that moment on he knew he wanted to be a pilot. Many of Dengler's stories of hunger and deprivation in the post-war years, along with his obsessions regarding flight, echo similar stories from Herzog's past[25]. After serving an apprenticeship as a blacksmith and church clock maker, Dengler emigrated to America and after years of struggle became a US Navy pilot. In 1966, during the very early stages of the Vietnam War, he was shot down over Laos on his very first military mission. Taken prisoner by the Pathet Lao, a communist movement in Laos, he endured periods of torture and starvation with a number of fellow prisoners of war before escaping six months later into the jungle. After enduring extraordinary hardships in the jungle, he was eventually rescued by US aircraft and returned to his ship.

In interviews Herzog explains how Dengler became an actor who played himself in the film:[26]

> Everything in the film is authentic Dieter, but to intensify him it is all re-orchestrated, scripted and rehearsed. It was my job as the director to translate and edit his thoughts into something profound and cinematic.[27]

As well as transforming Dengler into an actor Herzog mobilises the powers of the false and fabricates a number of sequences in the film, including Dengler's obsession with repeatedly checking whether doors are locked behind him ('I created from what he had casually mentioned to me, that after his experiences in the jungle he truly appreciated the *feeling* of being able to open a door whenever he wanted to.'[28]); contemplating having a tattoo of

death driving a horse-drawn chariot and telling the tattooist he would have to change the image to one of angels driving the chariot because 'death didn't really want me' ('Though it is true that he had hallucinations when he was near death by starvation in the jungle, of course Dieter never had any intention of really getting a tattoo. The whole thing was my idea.'[29]); the sequence where Dengler explains what his dreams of death are like being in front of a tank full of jellyfish ('In our conversations he described his dream to me in such a way that immediately an image of a jellyfish floated into my mind. It was almost dancing in a kind of slow-motion transparent movement, exactly the image that was needed to enable his dream to be articulated on screen. Dieter could not express it, so I did it for him and had him stand next to the water tank. I just took his words and enriched them with images, much like a scientist enriches uranium.'[30]); and Herzog's personal favourite, which occurs at the very end of the film, where Dengler is filmed at the aircraft graveyard at Davis-Monthan Air Force Base near Tucson, Arizona. Thousands of mothballed aircraft are parked in lines. From horizon to horizon there is nothing but aircraft. In this scene, which Herzog describes as one of the 'best examples of stylization in any of my films'[31], Dieter talks of the nightmares he had when he was rescued from the jungle and how his friends would take him from his bed at night and put him into the cockpit of an aircraft because it was the only place where he felt safe.

Wings of Hope explores the story of Julianne Koepcke, a German woman who was the sole survivor of a plane crash in the Peruvian jungle in 1971. Herzog himself narrowly avoided catching the same flight while location scouting for his feature film *Aguirre, Wrath of God*. This inspired him to go on and make the documentary.[32] In the film Herzog and Koepcke revisit the location of the crashed aircraft in the Peruvian jungle. Koepcke recounts her survival from the crash and her subsequent escape

from the dense jungle interior. As they fly to the crash site Herzog films Koepcke sitting anxiously in the same row of seats as she had prior to the disaster in 1971. Arriving in the jungle she unearths pieces of the wrecked aircraft hidden in the jungle foliage since the crash, and the retraces her steps as she stumbled injured for ten days to a small village where she was eventually rescued. Whilst this film is clearly stylised to a much lesser extent than *Little Dieter Needs to Fly*, those elements it does contain are striking.[33] The powers of the false almost completely consist of a series of invented dream sequences for this film. The film opens with a dream where Koepcke walks along a street peopled by burnt and broken mannequins in shop windows. Herzog's voice-over talks about how in her dreams the faces she encounters are broken: 'The heads are smashed, but she is not afraid.' Later, as she visits the archives of a natural history museum, she is described by Herzog as having a recurrent dream, a 'safeguard against the horror', where she visits a museum containing cabinets full of millions of petrified butterflies, 'all the species of the world'. 'It is as if she is locking away all the aircraft of the world so that they can't hurt her anymore'. As the footage shifts to her walking around a vast room containing skeletons, skins and taxidermied animals, the dream turns into a nightmare, where she finds that 'there are no more living beings, only trophies', petrified animals who will never stir again, according to Herzog they are 'caught in the abyss of time'[34].

The final sequence is another of Herzog's concluding gestures, echoing those at the end of *The Great Ecstasy of Woodcarver Steiner* and *Little Dieter Needs to Fly*. Interspersed with still photographs from her 1971 rescue, the camera rises from the jungle and Herzog describes how Koepcke dreams of returning to the jungle, finding all of the pieces of the wrecked aircraft, reassembling them and taking to the air. In a manner that recalls his brief poem to Steiner, Herzog describes her flight into the void, as if caught in a tunnel of time carrying her both backwards and

forwards. She dreams of seeing herself alone at the crash site, abandoned in the abyss of the jungle, being taken further and further away from herself. In her dreams of abyssal abandonment it dawns upon her that 'nothing can be reversed, nothing can be annulled'. She is hurled again and again into the void, into the darkness until she comes to rest and is offered a door of deliverance. She goes through the door and is engulfed in an angelic light, where all of her fear departs and she is overwhelmed by bliss and the knowledge that she is rescued. The camera continues to rise as Wagner's *Das Rheingold* plays. Koepcke is left behind in the jungle, on the ground, alone.

The White Diamond returns to themes explored in both *Little Dieter Needs to Fly* and *Wings of Hope*. This time Herzog's subject is the struggles of the British aeronautical engineer Graham Dorrington, who has built a teardrop-shaped airship and dreams of flying over and filming the forest canopies of Guyana. Dorrington is another of Herzog's visionaries, obsessed with flight and defying gravity. In the manner of Steiner and Dengler, he too dreams of flight, of being a bird soaring into the sky. Yet like Steiner, Dengler and Koepcke, he is also haunted by the resultant fall to earth and the struggle to survive. In Dorrington's case it is the guilt that accompanies his quest after the death of the cinematographer Dieter Plage during an earlier experimental flight of the prototype airship in Sumatra. Dorrington is given lines to recite by Herzog that present his desire to fly as being mythic, akin to the way Steiner and Dengler are presented. For Herzog, Dorrington's heroic quest to fly above the jungle suspended in an airship is the key to somehow resurrecting Plage – the idea of successfully launching the airship is to defy the jungle, gravity and death itself.

As part of a trajectory initiated by the two early documentaries *Lessons in Silence and Darkness* and *The Great Ecstasy of Woodcarver Steiner*, these three later documentaries form part of a vast opera of spiritual ecstasy. Heroic themes connect them: the

defying of gravity, the struggle for survival against the overwhelming forces of nature, the cruelty and brutality of man; solitude, transformation and resurrection. The powers of the false in these films are intense refrains, poetic injections into the fabric of represented reality. Each one of the films is a distinct movement in one vast opera in which Herzog can reveal the least understood truths of human existence.

Each of his documentary works contains a set of repeated musical motifs and thematic echoes. But there is one of his documentary films that is exemplary in this regard, almost completely structured as a self-contained tragicomic opera. This is his 1990 documentary *Echoes from a Sombre Empire*. It is clear that while film is capable of presenting our deepest aspirations, it is equally capable of presenting our foulest nightmares. In this film, as in *Lessons of Darkness*, Herzog's focus is on our nightmare. It is a film that Herzog himself describes as his attempt to 'explore the dark landscapes that lie at the heart of man.'[35]

Echoes from a Sombre Empire follows journalist Michael Goldsmith as he revisits the Central African Republic, where he was imprisoned and tortured by Jean-Bedel Bokassa's notorious regime for allegedly being a spy in the 1970s. Goldsmith was beaten and tortured by Bokassa personally. The film opens with Herzog refusing to speak for Goldsmith other than to read a letter from him. Goldsmith had disappeared whilst reporting in Liberia at the time of the film's release, and in the letter tries to explain the feeling of unreality and detachment he was left with after his experience of torture. Herzog does not appear again in the film, and does not provide the narrative voice-over recognisable from so many of his other documentaries. Perhaps what is most difficult for Goldsmith to put into words cannot be articulated by the direct narrative point of view of Herzog as the director. There simply is no straightforward explanation for humanity's mad excesses. The real task is to find a less direct, more allusive and poetic means to document them, in order that

it can serve as a reminder that such things exist, and that we have within ourselves the capacity for more evil than we ever care to admit. The letter read by Herzog also describes a fabricated dream that Goldsmith has, accompanied by images of the migration of the Christmas Island red crab.[36] There is an dreamlike quality to the footage of the red crabs, with a suggestion that they represent a dystopian plague invading the world. This is essentially linked to the subsequent story of this mad late-twentieth century emperor, the hallucinated and poisonous product of European colonialism.

During the course of the film Goldsmith interviews two of Bokassa's wives, several of Bokassa's children, two of Bokassa's lawyers, and Central African Republic President David Dacko. Bokassa appears through remarkable stock footage shot by journalists in the 1970s, including footage shot at the time of his proclamation of the Central African Empire (CAE) and his sublimely absurd coronation in 1977.[37] Goldsmith was working as a French journalist when he was imprisoned after reporting on Bokassa's elaborate coronation. In the film, he says that he had written his report and used a telex machine to send it to his employer. There was a power failure during the transmission, causing the text to become jumbled. The message was intercepted by a government official, who decided that it was a coded message, and that Goldsmith was a South African spy. Goldsmith was imprisoned, beaten by Bokassa almost to death, and tortured by members of his security police.

Through a rich operatic tapestry of historical footage, that reaches an almost poetic level of intensity and hallucinatory suggestion, the insane and dark violence of Bokassa's Central African Empire is presented. From the baroque ceremonies associated with the establishment of Bokassa's Empire to sequences that hint at the reality of its Hobbesian excesses, this documentary achieves a singular intensification of reality, communicating a deep truth of the madness and violence of

European colonialism. Bokassa is revealed to be the bastard offspring of two centuries of European colonialism, himself a product of French colonialism and militarism, returning to rule over his country as its worse nightmare. Throughout the film there are repeated visual and narrative clues to the way the forces of Western imperialism are thoroughly implicated both in Bokassa's rise to power in the toleration of his authoritarian excesses. Bokassa yearned to enact a Napoleonic empire, mimicking all of its early nineteenth century ceremonial extremes and centralised tyranny. Herzog, working more like a classical composer, carefully arranges the sequences like movements in a vast comic opera. Fragments of Bokassa's diminutive young son in full military regalia falling asleep on a throne beside the newly crowned Emperor and his wife are interspersed with poignant scenes of military aides struggling to put on the child's ceremonial white gloves or sitting perilously balanced on a high cushion beside the Emperor's vast Eagle-clad coronation throne. Footage of Bokassa's Napoleonic excesses continue to be played out as Goldsmith uncovers detail after detail of his murderous and allegedly cannibalistic tyranny. A comic sequence occurs at the beginning of the film, immediately after Herzog's strange hallucinatory introduction. Goldsmith is shown visiting Bokassa's chateau in France where he lived with his wife and children in exile, after being deposed. Bokassa, at this point was in a military prison in CAR, after having chosen to return from exile, despite being sentenced to death in his absence. Goldsmith is allowed into the chateau and is filmed wordlessly examining the bizarre relics of Bokassa's Napoleonic Empire. Vast portraits of Bokassa in full imperial garb adorn the vast walls. They hang alongside busts of Napoleon, portraits of his children and other historical relics of Empire. Herzog's aim is to pull the audience into the twisted magic of something 'very, very strange, something that looks familiar but becomes unfamiliar.'[38]

Herzog will resurrect this dystopia however he sees fit. The

final sequence of *Echoes From a Sombre Empire*, a shot of a smoking chimpanzee, is one of Herzog's key moments. It crowns this dystopian nightmare, where the ecstatic striving and yearning for a transcendent and sublime existence has become toxic, with a truly tragic yet comic spectacle. Herzog begins the sequence by filming Goldsmith as he tours the decaying remains of Bokassa's private zoo. This is where Bokassa reputedly threw prisoners to lions and crocodiles. The zoo's last remaining employee shows Goldsmith around and then asks for a cigarette, only to give the cigarette to a caged chimpanzee, who smokes it as though he's done it his whole life. By this point, Goldsmith has interviewed dozens of Bokassa's relations, employees and prisoners and heard (re-heard, more likely) countless stories of the atrocities committed by Bokassa. It is only when he sees the chimp smoke, though, that he turns to the camera and says:

> Goldsmith: 'Werner, I can't stand this anymore. Can you turn it off now?'
> Herzog: 'Michael, I think this is one of the shots that I should hold.'
> Goldsmith: 'You promise that this will be the end shot – it will be the last shot in the film?'
> Herzog: 'Yes, I promise.'

Herzog, when asked about this sequence in an interview, said:

> In the decrepit zoo we found one of the saddest things I have ever seen: a monkey addicted to cigarettes thanks to the drunken soldiers who had taught it to smoke. Michael Goldsmith looks at the ape and says something like, 'I can't take this any longer' and tells me I should turn the camera off. I answer back from behind the camera, 'Michael, I think this is one of the shots I should hold.' He replies, 'Only if you promise this will be the last shot in the film.' While this

dialogue and my use of the animal was a completely scripted invention, the nicotine-addicted monkey itself was not. There was something momentous and mysterious about the creature, and filming it in the way I did brought the film to a deeper level of truth, even if I did not stick entirely to the facts.[39]

No matter how dystopian Herzog's vision may be, and it is very dark indeed in both *Echoes of a Sombre Empire* and *Lessons of Darkness*, it always has the quality of music, poetry and art. It is art, and the art of film, that can offer us the kind of redemptive glory that Herzog describes at the end of *Wings of Hope*. It is this that he recognises from our earliest attempts to create a dream of transformation and ecstatic yearning on the cave walls at Chauvet. This ancient yearning is, for Herzog, the utopian optimism associated with art, and the art of the film. This optimism has the potential to re-enchant the world. This is to be distinguished from the cinematic regime that remains disastrously caught up with the actual, with the 'factual', and the impoverished field of images in the mass media. For Herzog it is always a matter of a new poetic truth created through a form of counter-sense cinema, a form that has fully embraced the powers of the false. Herzog's fabulated documentaries are the types of film that can once again provide us a sense of the intense dynamism and complexity of life. These are the films that will pull and stretch our imagination into new shapes, transporting us into new and uncharted places. They are visionary spectacles of a new 'inland empire'. In its capacity to create such ecstatic truths, to elaborate new mythologies for the future, the cinema has the ability to wrench us out of the present and to found a new people and a new earth. It just needs to wake up from its sterile and anesthetised state and become fully aware of it.

Conclusion

The Eye and the Razor

I have the impression that the images that surround us today are worn out; they are abused and useless and exhausted. They are limping and dragging themselves behind the rest of our cultural evolution. What have we done to our images? We need images in accordance with our civilization and our innermost conditioning, and this is the *reason why* I like any film that searches for new images no matter in what direction it moves or what story it tells. One must dig like an archaeologist and search our violated landscape to find anything new. It can sometimes be a struggle to find unprocessed and fresh images.[1]
Werner Herzog

In the opening scenes of Luis Buñuel and Salvador Dali's 1929 silent surrealist masterpiece *Un Chien Andalou* a middle-aged man sharpens his razor at his balcony door before testing its sharpness on his thumb. He then opens the door, plays with the razor while gazing up at the moon, which is about to be engulfed by a thin white cloud. There is a cut to a close-up of a young woman being held from behind by the man as she stares, calm, straight ahead. Another cut occurs to the moon being overcome by a cloud; the man slits the woman's eye with the razor, the vitreous humour spills out.

Cinema, like poetry, is capable of revealing dimensions of meaning that are deeper than the level of truth on the surface of things. Cinema has the capacity to disturb our perceptual habits and everyday patterns of thought, to suggest new ways of perceiving the world, new emotional affects and new ways of thinking. These dimensions of truth can be immeasurably deeper

than those reached by much contemporary Hollywood cinema. A realm beyond prosaic reality, it provides some of the most fertile areas for filmmakers.

Through its reduction to instantaneous and easily consumed mass-media representation, the complex ontological stratum of the world has become increasingly levelled. Everything represented has become surface without depth – a screen. Many of us feel alienated from this surface, having lost our grasp upon its smooth and depthless skin. We have become marked by less and less commitment to the reality of the world; its past and its future are impossibly removed from us. We exist enchained to the present, unencumbered by either the layers of the past or alternative visions of the future, floating in a frictionless surface state without any depth coordinates.

This ontological nihilism cannot be challenged through the straightforward cultivation of 'facts' or by an obsessive raking over of the actual, it must also be confronted by a rejuvenated sense of our own capacity to transform and rediscover deeper 'truths' in the world. It is absolutely vital that we strive to become simultaneously historical and futural. In other words, we must work towards discovering the means to cut ourselves free from our present state and become something else, the coordinates of which cannot be found in the 'factual' conditions of the present. The succession of imagery in cinema can recount our inner lives – our complex psycho-spiritual histories, our hopes and aspirations, our dreams and fantasies, and our collective madness. Through poetry, it chronicles our inner spiritual voyages, the adventurous spirit of humanity's extraordinary exodus, and enables us to collectively experience the least understood truths about ourselves.

A process of poetically re-enchanting a world that has become fatally commodified and eroded by the viral forces of contemporary capitalism, has to be activated through cinema. This filmic re-enchantment offers the hope of an emergence of a vital faith in

the possibility of living differently again; of seeing, thinking and being in ways that can circumvent the myopic present, a present in which certain disastrous drives and desires have been unleashed and allowed to dominate all life. The counter-sensible strategies, oneiric explorations and poetic myth-building associated with the art of cinema carried out by some of the film directors discussed in this book (e.g. Haneke, Lynch and Herzog) offer powerful tools for the recreation of a visual space of open possibility capable of confronting the shrinking boundaries of the present. However, cinema does not remain confined to such paths – other, perhaps stranger, crueller and more mysterious byways await cinema. It just needs to take the risk and to sever the ties that presently bind it.

As Herzog recognizes, the familiar cinematic language of common sense, which remains anchored to the reality of surfaces and to a naturalistic understanding of human cognition as something invariable, is utterly ill equipped to bring us back into proximity with the complex and multi-faceted nature of ourselves and the world. It is even less capable of challenging the disastrous cultural nihilism that confronts us. Stranger and less familiar approaches are required in order that we might once again catch a glimpse of hidden truths and to begin to cultivate new forms of optimistic belief in the world as it is – oblique, elliptical and counter-sensible cinematic means. Within mainstream Hollywood cinema, despite its hyper-technological prowess, there exists an impoverished palette of images that reify a grotesque caricature of what both we and the world are. Myopic narcissism of the present results in forms of cinema that simply orient us repeatedly back upon a monolithic set of narrow possibilities – this is a nightmarish amphitheatre where films such as Dennis Dugan's *Jack and Jill* (2011), Stephen Sommers's *G.I. Joe: The Rise of Cobra* and Roland Emmerich's *2012* are screened back-to-back, twenty-four hours a day, every day. Repeated trips to the cinema feel like an eternal circle in which

everything is different yet fatally the same. Like the never-ending quest for a sharper razor with even more blades that will provide an ever-closer shave, we are still essentially being sold the same old thing – a razor. We must grasp this razor, in the manner of Dali and Bunuel, and slice apart the eye of the present so that a future vision is unleashed, or slit our throats from boredom.

Endnotes

Introduction

1 Mark Fisher, *Capitalist Realism* (Zero Books, 2010)

Chapter 1

1 Andre Bazin, *What is Cinema*, Vol. 1, revised edition (University of California Press), p.14 (my emphasis)

2 Stanley Cavell, *The World Viewed* (Harvard University Press, 1980), p. 18

3 Ibid, p.21

4 See Noel Carroll, *Engaging the Moving Image* (Yale University Press, 2003)

5 'Hitchcock introduces the mental image into the cinema. That is, he makes relation itself the object of an image, which is not merely added to the perception, action and affection images, but frames and transforms them. With Hitchcock, a new kinds of 'figures' appear which are figures of thought.' (Deleuze, *Cinema 1: The Movement Image* (Continuum, 1986), p. 203

6 Noel Carroll, *The Philosophy of Motion Pictures*, revised edition (Wiley-Blackwell, 2007) p.143

7 David Bordwell, 'Cognition and Comprehension' in *Journal of Dramatic Theory and Criticism* 6 (1992) no. 2, p. 183

8 Ibid, p. 185

9 Ibid, p. 185

10 Michel Foucault, *The History of Sexuality*, Vol. 1, new edition (Penguin, 1998), p. 86

11 Jean Baudrillard, *The Conspiracy of Art* (Semiotext(e), 2005), pp. 112-3

12 Ibid, p. 120

13 Ibid, p. 114

14 Ibid, p. 115

Chapter 2

1 See the work of Daniel Wojcik on apocalyptic thinking, especially his article 'Embracing Doomsday: Faith, Fatalism, and Apocalyptic Beliefs in the Nuclear Age' published in Western Folklore, Vol.5, no.4, 1996

2 Martin Buber, *Pointing the Way: Collected Essays* (Routledge & Kegan Paul, 1957), p. 201

3 Slavoj Žižek, *Living in the End Times*, (Verso, 2010), p. 336

4 Friedrich Nietzsche, *On the Genealogy of Morals*, translated by Walter Kaufmann (Vintage Books, 1989), p.68

5 It is worth mentioning at this point the rather startling set of basic limitations that these supposedly technologically advanced alien invaders possess, which include an inability to break out of cupboards, a lack of sophisticated mapping techniques to such an extent that they are entirely reliant upon the existence of corn fields across different parts of the globe in which to trace invasion maps, and their poor judgement in choosing not to wear protective clothing whilst on the surface of the water-rich Earth despite their fatal aversion to water. If one were being generous to Shyamalan, one might suggest that these poorly conceived aliens are really only present in the film as elaborate ciphers for evil within a narrative that's real concerns lie very much elsewhere than science-fiction.

6 It is interesting to note that such a viewpoint is already intimated earlier in the film by the character Ray Reddy (played by Shyamalan) who, it is revealed, was responsible for the accident that killed Colleen. He explains his own incredulity surrounding the events leading up to the accident, and suggests that it is as if it were meant to be. Even the character's name suggests his own 'readiness' for the apocalypse.

7 There is a telling reference to Wells' story in Shyamalan's 2002 Signs that serves to symbolically connect these two

particular films. As the Hess family gather round the television to watch reports of UFOs appearing in the skies around the globe Merrill exclaims that "it is just like *War of the Worlds!*"

8 Stephen Spielberg, from an interview in 2005
9 Cormac McCarthy, *The Road* (Picador, 2009), p. 74
10 Ibid
11 Cormac McCarthy, *Sunset Limited* (Picador, 2010), p. 104
12 Cormac McCarthy, *The Road*, p. 75
13 The only comparable contemporary filmmaker is the Hungarian Béla Tarr, who has created a similarly indefinable post-apocalyptic landscape in work such as *Sátántangó* (1994), *Werkmeister harmóniák* (2000) and *A torinói ló* (2011).
14 From an interview with Michael Haneke.
15 They are only vaguely defined as being of Middle Eastern origin.
16 In a footnote of his recent book on Tarkovsky's film *Stalker*, Geoff Dyer notes the extent to which Haneke's final shot in *Time of the Wolf* alludes (or quotes) the shot of the three characters travelling into the 'zone' aboard the train cart in *Stalker*. He writes – 'The refugees from an unexplained all-engulfing catastrophe are holed up at a railway station where they hope to be able to stop and board one of the trains rumoured to be heading south. The hope offered by these trains becomes increasingly forlorn as conditions and social relations deteriorate. The film's narrative comes to an end. Then there is a long sequence shot from a train, of landscape rushing past, speed-blurred in the foreground, unspoiled and apparently unthreatened in the distance...There is no sign of devastation, though it is possible that it has recently been cleansed, not only ethnically but humanly. It has also been emptied of all clues as to what it might mean. There is no explanation of what this train is or where it is heading. The landscape rushing past

refuses to sanction any symbolic reference to what has gone before. Trees and Sky are absolutely unimbued. Then black. The end.' (Geoff Dyer, *Zona* (Knopf Doubleday Publishing Group, 2012), footnote 13)

17 See Michael Haneke's essay 'Terror and Utopia of Form. Addicted to Truth: A Film Story about Robert Bresson's *Au hazard Baltazhar*' in *A Companion to Michael Haneke*, ed. Roy Grundmann (Wiley-Blackwell, 2011), p. 569

Chapter 3

1 Martin Heidegger, *What is Called Thinking?* (HarperPerrenial, 1976), p. 4

2 Slavoj Žižek, *Living in the End Times*, p. 336

3 Gilles Deleuze, *Cinema 2: The Time-Image* (Continuum, 1989), p. 156

4 Ibid, p. 179

5 Ibid, pp. 179-80

6 Ibid, p.213

7 Ibid, p.278

8 Ibid, p. 181

9 Ludwig Wittgenstein, *Lectures and Conversations on Aesthetics, Psychology, and Religious Belief* (Wiley-Blackwell, 1970), pp. 45-6

10 Ludwig Wittgenstein, *Culture and Value* (Wiley-Blackwell, 1998), p. 68

11 Slavoj Žižek, *The Art of the Ridiculous Sublime: On David Lynch's 'Lost Highway'* (University of Washington Press, 2000)

12 A *moebius strip* is a paradoxical geometrical shape that has one continuous surface despite being formed from a band with two distinct surfaces. The effect is produced by a simple half twist.

13 Slavoj Žižek, Ibid, p. 14

14 In this respect there are many striking parallels between Lynch's *Mulholland Drive* and Godard's 1963 film *Le Mepris*.

15 This technique is one Lynch has used from his very earliest films. In his first films *The Alphabet* and *The Grandmother*, Lynch painted the entire interior of his house black and shot the films there. He said it was in order that the viewer focussed on 'what was happening there and not on the background detail'. This principle of visual isolation resonates powerfully with the painter Francis Bacon who often set his deformed figures against flat monochrome fields of bright colour. As in Bacon's paintings, the figures in this jitterbug sequence are presented as if within a zone of pure interiority, outside the co-ordinates of natural space and time where Lynch presents a frenetic dance of abstract figures.

16 Michel Chion, *David Lynch*, 2nd Ed. (University of California Press, 2007), p. 22

17 Ibid.

Chapter 4

1 Werner Herzog, 'On the Absolute, the Sublime, and Ecstatic Truth', originally delivered as a speech in Milano, Italy in 1992, p. 1

2 For Herzog, 'if we do not develop adequate images we will die out like dinosaurs' from Paul Cronin (Ed.) *Herzog on Herzog* (Faber & Faber, 2002), p. 66

3 From *Fata Morgana* onwards Herzog has undertaken a unique cinematic process of mythologizing the landscape of the Earth as a means of figuring internal psychological or spiritual space. An emphatic documentary presentation of the material world (both beautiful and ruined) is trans-figured into an expression of the human collective psyche. *Fata Morgana* remains one of Herzog's boldest and most experimental documentaries, to such an extent that many filmographies do not even acknowledge it as a documentary at all. In this film surreal images of miracles, landscapes and

desert dwellers are arranged into three parts (1) The Creation, (2) Paradise and (3) The Golden Age, which are accompanied by narration from Popol Vuh, the Mayan book of creation myths and history, which is read by the renowned French-German film historian and critic Lotte Eisner. Herzog's original concept for the film was for it to be a documentary pieced together from footage shot by extraterrestrials that have landed on a strange planet and discover a people awaiting an impending collision with the sun. For Herzog the film would allow the audience to witness how aliens might perceive our own planet. Despite the fact that he chose not to pursue this approach for *Fata Morgana*, Herzog extrapolated upon it in later documentary work such as *Lessons in Darkness* (1992) and *Wild Blue Yonder* (2005) where an alien played by Brad Dourif, contemplates life on our planet using stock footage of the Earth shot by NASA and striking underwater scenes.

4 Herzog, 'On the Absolute, the Sublime, and Ecstatic Truth', p. 1

5 Herzog's central idea of 'ecstatic truth' is akin to what Gilles Deleuze calls the 'powers of the false' in his theoretical writing on cinema. Both ideas challenge the fixed form of truth associated with the classic forms of cinematic representation which persists in much contemporary Hollywood cinema.

6 Stanley Cavell, *The World Viewed*, p.21

7 Gilles Deleuze, *Cinema 2: The Time-Image*, p. 137

8 Ibid, pp. 184-5

9 Any one of these filmmakers could have been the subject of a separate chapter in this book. Once other possible names began to be admitted, e.g. Tarkovsky, Bresson, Bergman, Ozu, Ray, Rossellini, Kiarostami, Weerasethakul and Noe, I realized certain decisions had to be made.

10 Christopher's Nolan's recent film *Inception* (2010) remains a

failure in this regard, despite ambitions to the contrary. It offers merely the corporate sheen of cinematic experimentation. Qualitative anomalies and *aporias* associated with the aberrant dream space are re-mapped and re-organized according to an orthodox quantitative schema. This quantitative schema is nothing more than the familiar and well-worn paradigm of normative Hollywood filmmaking. The truthful man lives to make another film.

11 Gilles Deleuze, Ibid, p.129

12 Ibid, p.131

13 Gilles Deleuze, *Cinema 1: The Movement-Image*, p. 184

14 Ibid.

15 Paul Cronin (ed.), Ibid, p. 70

16 Noel Carroll, *Interpreting the Moving Image*, p.292. See also the striking sequence in *Lessons of Darkness* which involve the only two interviews included. These are short but extremely powerful. Both are linked by the fate of the victims, in the first a mother watched as her two sons were tortured, since then she is no longer able to speak. Instead she murmurs and uses her hands to articulate her on-going pain and suffering. The second involves a young woman and her young child, she first explains the effects of the smoke, and then her encounter with soldiers who killed her husband and nearly killed her son. At the time of the interview, it had been a year since this has happened, in all that time her son has only ever spoken once; to tell his mother he never wants to learn to speak. The unspeakable nature of this horror is explicitly referenced by the two mothers, and rendered physically palpable by Herzog's filmmaking.

17 Haptic refers to the sense of touch, and is a form of nonverbal and tactile communication.

18 A scenario Herzog would return to later in his feature film *The Enigma of Kasper Hauser*.

19 Paul Cronin (ed.), Ibid, p. 72

20 Herzog - 'I have always felt very close to ski-jumpers. I literally grew up on skis and, like all the kids in Sachrang, dreamt about becoming a great ski-jumper and national champion.' (Paul Cronin (ed.), Ibid, p. 95)

21 Noel Carroll, *Interpreting the Moving Image*, p. 292

22 Herzog - 'with Swiss ski- jumper Walter Steiner there was someone who could fly like a bird, someone who could physically experience everything I once dreamed of: overcoming gravity.' (Paul Cronin (ed.), Ibid, p. 95)

23 Paul Cronin (ed.), Ibid, p. 96

24 Ibid, p. 96

25 In many interviews Herzog has noted such events from his own childhood in Bavaria, witnessing allied bombing raids, devastated bombed-out ruins and his own dreams of flight (albeit ski-flight).

26 The documentary was eventually re-made by Herzog as a feature film, *Rescue Dawn* (2007), with Christian Bale playing the part of Dieter Dengler.

27 Paul Cronin (ed.), Ibid, p. 265

28 Ibid, p. 266

29 Ibid

30 Ibid, p. 270

31 Ibid, p. 266

32 Herzog encountered many difficulties in tracking down Julianne before finally getting her to agree to do the film. Her subsequent anonymity and reluctance to become involved in any film project related to her experiences were largely due to the appalling feature film that was made shortly after her rescue from the jungle. Short sequences of this film are in fact shown during Herzog's film to illustrate the point.

33 When asked about the minimal use of stylized 'ecstatic truth' in *Wings of Hope*, Herzog said - There were some very personal things that Julianne did not want to talk about, and

she knew I would always respect her wishes on things like that. My decision not to introduce too many stylized elements into the film was probably something to do with her character. Julianne is a scientist, very straight-talking and clear-headed, and the only reason she survived her ordeal was because of her ability to act methodically through those absolutely dire circumstances.' (Paul Cronin (ed.), Ibid, p. 270)

34 This scene clearly alludes to the scene in Chris Marker's *La Jetee* (1962), where the time-traveler visits the exhibition of taxidermied creatures with the woman from his memory at the Paris Natural History Museum and contemplates their petrified abandonment to time.

35 Paul Cronin (ed.), Ibid, p. 216

36 Herzog used the same footage of the crab migration in his later film *Invincible* (2001).

37 His baroque regalia, lavish coronation ceremony and regime of the newly formed Central African Empire (CAE) were largely inspired by Napoleon I. The coronation ceremony was estimated to cost his country roughly 20 million US dollars. Bokassa attempted to justify his actions by claiming that creating an empire would help Central Africa 'stand out' from the rest of the continent, and earn the world's respect. The 1977 coronation ceremony consumed one third of the CAE's (Central African Empire) annual budget and all of France's aid money for that year.

38 Paul Cronin (ed.), Ibid, p. 219

39 Paul Cronin (ed.), Ibid, p. 242

Conclusion

1 Paul Cronin (ed.), *Herzog on Herzog*, p. 66

Bibliography

Andre Bazin, *What is Cinema*, Vol. 1, revised edition (University of California Press, 2004)

Jean Baudrillard, *The Conspiracy of Art* (Semiotext(e), 2005)

David Bordwell, 'Cognition and Comprehension' in *Journal of Dramatic Theory and Criticism* 6 (1992) no. 2.

Martin Buber, *Pointing the Way: Collected Essays* (Routledge & Kegan Paul, 1957)

Noel Carroll, *Engaging the Moving Image* (Yale University Press, 2003)

Noel Carroll, *The Philosophy of Motion Pictures*, revised edition (Wiley-Blackwell, 2007)

Stanley Cavell, *The World Viewed* (Harvard University Press, 1980)

Michel Chion, *David Lynch*, 2nd Ed. (University of California Press, 2007)

Paul Cronin (ed.) *Herzog on Herzog* (Faber & Faber, 2002)

Gilles Deleuze, *Cinema 1: The Movement Image* (Continuum, 1986)

Gilles Deleuze, *Cinema 2: The Time-Image* (Continuum, 1989)

Geoff Dyer, *Zona: A Book About a Film About a Journey to a Room* (Knopf Doubleday Publishing Group, 2012)

Mark Fisher, *Capitalist Realism* (Zero Books, 2010)

Michel Foucault, *The History of Sexuality*, Vol. 1, new edition (Penguin, 1998)

Roy Grundmann (ed.), *A Companion to Michael Haneke* (Wiley-Blackwell, 2011)

Martin Heidegger, *What is Called Thinking?* (HarperPerrenial, 1976)

Werner Herzog, 'On the Absolute, the Sublime, and Ecstatic Truth', originally delivered as a speech in Milano, Italy in 1992

Cormac McCarthy, *The Road* (Picador, 2009)

Cormac McCarthy, *Sunset Limited* (Picador, 2010)

Friedrich Nietzsche, *On the Genealogy of Morals*, translated by

Walter Kaufmann (Vintage Books, 1989)

Ludwig Wittgenstein, *Lectures and Conversations on Aesthetics, Psychology, and Religious Belief* (Wiley-Blackwell, 1970)

Ludwig Wittgenstein, *Culture and Value* (Wiley-Blackwell, 1998)

Daniel Wojcik, 'Embracing Doomsday: Faith, Fatalism, and Apocalyptic Beliefs in the Nuclear Age' in *Western Folklore*, Vol.5, no.4, 1996

Slavoj Žižek, *The Art of the Ridiculous Sublime: On David Lynch's 'Lost Highway'* (University of Washington Press, 2000)

Slavoj Žižek, *Living in the End Times*, (Verso, 2010)

Filmography

What follows is a list of the main films watched and then referenced within this book. It is by no means an exhaustive list. It does, however, contain many extraordinary films which were a pleasure to re-watch for the purposes of writing this book. It also contains a handful of abominable movies which were tortuous experiences to endure.

Armageddon (Michael Bay, 1998)
A Man Escaped (Robert Bresson, 1956)
Pickpocket (Robert Bresson, 1959)
Joan of Arc (Robert Bresson, 1962)
Un Chien Andalou (Luis Bunuel & Salavador Dali, 1929)
It's A Wonderful Life (Frank Capra, 1946)
Casablanca (Michael Curtiz, 1942)
The Day After Tomorrow (Roland Emmerich, 2004)
2012 (Roland Emmerich, 2009)
The Searchers (John Ford, 1956)
Les Mepris (Jean-Luc Godard, 1963)
The Road (John Hillcoat, 2009)
Rope (Alfred Hitchcock, 1948)
Rear Window (Alfred Hitchcock, 1954)
Vertigo (Alfred Hitchcock, 1958)
The Seventh Continent (Michael Haneke, 1989)
Benny's Video (Michael Haneke, 1992)
71 Fragments of a Chronology of Chance (Michael Haneke, 1994)
Funny Games (Michael Haneke, 1997)
The Piano Teacher ((Michael Haneke, 2002)
Time of the Wolf (Michael Haneke, 2003)
Even Dwarfs Started Small (Werner Herzog, 1970)
Land of Silence and Darkness (Werner Herzog, 1971)
Fata Morgana (Werner Herzog, 1972)

Aquirre, the Wrath of God (Werner Herzog, 1972)

The Enigma of Kaspar Hauser (Werner Herzog, 1974)

The Great Ecstasy of the Woodcarver Steiner (Werner Herzog, 1974)

Heart of Glass (Werner Herzog, 1976)

Stroszek (Werner Herzog, 1977)

Nosferatu the Vampyre (Werner Herzog, 1979)

Fitzcarraldo (Werner Herzog, 1982)

Echoes from a Sombre Empire (Werner Herzog, 1990)

Lessons of Darkness (Werner Herzog, 1992)

Little Dieter Needs to Fly (Werner Herzog, 1997)

Wings of Hope (Werner Herzog, 2000)

The White Diamond (Werner Herzog, 2004)

Wild Blue Yonder (Werner Herzog, 2005)

Grizzly Man (Werner Herzog, 2005)

Encounters at the End of the World (Werner Herzog, 2007)

My Son, My Son, What Have Ye Done (Werner Herzog, 2009)

The Cave of Forgotten Dreams (Werner Herzog, 2011)

The Book of Eli (The Hughes Brothers, 2010)

Donnie Darko (Richard Kelly, 2001)

Deep Impact (Mimi Leder, 1998)

Once Upon a Time in the West (Sergio Leone, 1968)

Star Wars (George Lucas, 1976)

The Alphabet (David Lynch, 1968)

The Grandmother (David Lynch, 1970)

Eraserhead (David Lynch, 1976)

The Elephant Man (David Lynch, 1980)

Dune (David Lynch, 1984)

Blue Velvet (David Lynch, 1986)

Twin Peaks - TV Series (David Lynch & Mark Frost, 1991-2)

Wild at Heart (David Lynch, 1991)

Twin Peaks - Fire Walk With Me (David Lynch, 1992)

Lost Highway (David Lynch, 1997)

The Straight Story (David Lynch, 1999)

Mulholland Drive (David Lynch, 2002)

INLAND EMPIRE (David Lynch, 2008)

La Jetee (Chris Marker, 1962)

Regarding Henry (Mike Nichols, 1991)

Memento (Christopher Nolan, 2000)

Inception (Christopher Nolan, 2010)

The Adjustment Bureau (George Nolfi, 2011)

Knowing (Alex Proyas, 2009)

Last Year in Marienbad (Alain Resnais, 1961)

Signs (M. Night Shyamalan, 2002)

The Village (M. Night Shyamalan, 2004)

The Happening (M. Night Shyamalan, 2008)

War of the Worlds (Stephen Spielberg)

Pulp Fiction (Quentin Tarantino, 1994)

Stalker (Andrei Tarkovsky, 1979)

Sátántangó (Béla Tarr, 1994)

Werkmeister harmóniák (Béla Tarr, 2000)

A torinói ló (Béla Tarr, 2011)

Gilda (Charles Vidor, 1946)

Sunset Boulevard (Billy Wilder, 1950)

Contemporary culture has eliminated both the concept of the public and the figure of the intellectual. Former public spaces – both physical and cultural – are now either derelict or colonized by advertising. A cretinous anti-intellectualism presides, cheerled by expensively educated hacks in the pay of multinational corporations who reassure their bored readers that there is no need to rouse themselves from their interpassive stupor. The informal censorship internalized and propagated by the cultural workers of late capitalism generates a banal conformity that the propaganda chiefs of Stalinism could only ever have dreamt of imposing. Zer0 Books knows that another kind of discourse – intellectual without being academic, popular without being populist – is not only possible: it is already flourishing, in the regions beyond the striplit malls of so-called mass media and the neurotically bureaucratic halls of the academy. Zer0 is committed to the idea of publishing as a making public of the intellectual. It is convinced that in the unthinking, blandly consensual culture in which we live, critical and engaged theoretical reflection is more important than ever before.